UPPINGHAM &
THE VILLAGES

THROUGH TIME

BARROWDEN, BELTON, EDITH WESTON, KETTON, NORTH & SOUTH LUFFENHAM

Trevor Hickman

AMBERLEY PUBLISHING

Contents

Introduction

In the engraving below, half of William Kips' original map of Rutland is published. This is divided into three districts around Uppingham listed as: No. 3 Martinsley Hundred, No. 4 Wrandick Hundred and No. 5 East Hundred. Twenty-eight villages are indicated, with a church. This map indicates part of Rutland south of the River Gwash. Today, thirty-one hamlets and villages are included in this presentation.

I have compiled this book as an enthusiast for the county of Rutland. In this book I have included numerous old photographs, as well as a collection of modern photographs taken by myself and my granddaughter Amy. Both of us have a deep interest in exploring the area around Uppingham. We visited as many churches as possible to view the interiors, although unfortunately many were locked. Fortunately, a fine collection of historic public houses were open in many of the delightful villages listed in this book. It is a tragedy that many public houses have been closed during the last ten years. Pubs must serve fine ale and fine food if they are to survive in the twenty-first century.

Thomas Fuller in his *History of the Worthies of England*, published in 1662, wrote, 'Let not the inhabitants of Rutland complain, that they are pinned up within the confines of a narrow county; seeing the goodness thereof equals any shire in England for fertility of ground: But rather let them thank God, who hath cast their lot into so pleasant a place, giving them a goodly heritage.'

This book is presented to the reader by an author who has explored this interesting county for over seventy years.

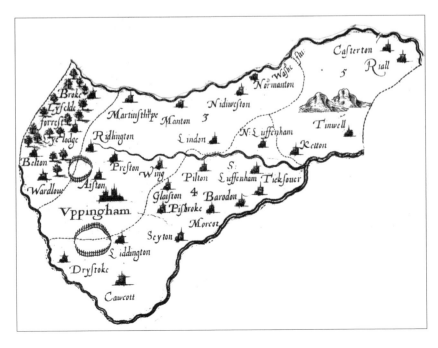

Rutland
William Kips'
map of Rutland
published in 1607.

ONE

South of the Gwash

In this chapter I feature thirteen villages and hamlets that are steeped in history. I could not consider which village is more interesting than its neighbours. Of course, any village that I have visited many times, especially to view its archaeology, has always been very important to me. In the 1970s, when Rutland Water was being planned, I was personally involved in excavating a medieval cottage in Lower Hambleton, under the direction of Fred Adams. Some of the artefacts that were discovered during 'the dig' are now on display in the County Museum at Oakham. Possibly the most important archaeological site is at Little Casterton, an interesting Roman settlement.

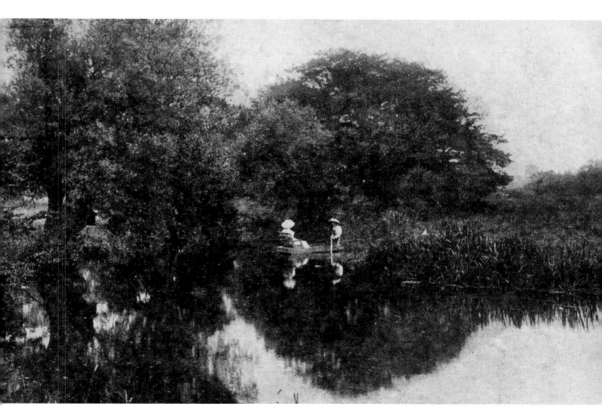

Boating at Little Casterton
Boating on 'the Gwash' at Little Casterton, 1903.

Belmesthorpe

Left: **Belmesthorpe Dovecote**
Belmesthorpe is a small village to the end of the A6121 road on the Lincolnshire border, near the River Gwash. This is a fine dovecote standing in Belmesthorpe, converted into a private house in 2007.

Below: **The Blue Bell Inn**
A fourteenth-century farmhouse that has been converted into a public house. In 1846, this farmhouse was occupied by James Bollans, who also produced and sold beer from the hatch that opened onto the highway. This is clearly visible on this photograph taken in 2007. By 1863 James had died and his wife Ann was selling beer and acting as a butcher for her son Charles, who was running their farm. In 1877 William Quincy, a butcher, was selling ale from this building. After his death his wife Frances ran this ale house. By 1916, during the First World War, Elizabeth Munton ran it as a public house, and on through the 1920s. When the Second World War began, Thomas Butcher had taken over the licence of The Blue Bell Inn by 1941.

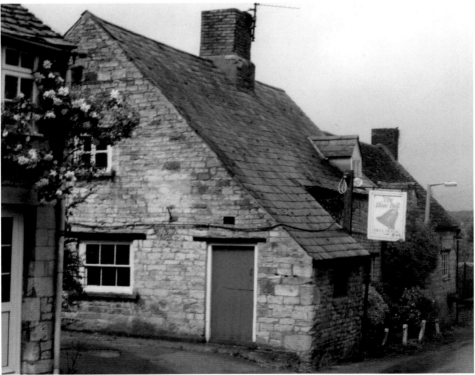

Ryhall

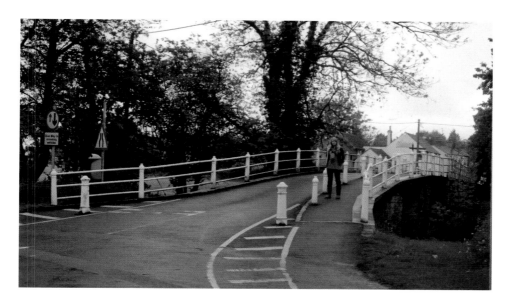

The Pack Horse Bridge, Ryhall

Above, Amy Grech standing on the Pack Horse Bridge in Ryhall, May 2007. In the background is The Millstone public house. This bridge was constructed across the fast-flowing river in 1600. A stone-built structure with two cutwaters, it was widened in the late eighteenth century, and eventually the roadway was supported with 'L' shaped iron girders in the late nineteenth century. Below, an Edwardian lady with her children standing on the Pack Horse Bridge in 1908. In the background is the Wesleyan chapel, erected in 1878, and the Tally Ho public house.

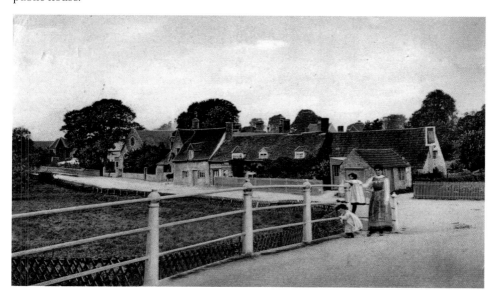

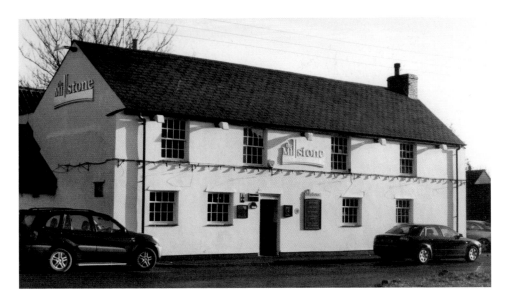

The Millstone

The Millstone public house, Bridge Street, Ryhall, December 2005. This was erected near the watermill that stood on the River Gwash. In 1846 John Lowe was the miller and William Leasing was the landlord of this hostelry. At the turn of the twentieth century John James Barnes 'J. J.' was the landlord of The Millstone. This historic name was retained through to the twenty-first century.

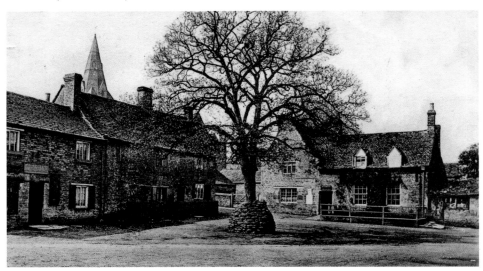

Market Square, Ryhall

The market square at Ryhall, surrounded with some interesting houses and shops in 1910. Behind the sycamore tree is The Green Dragon public house, when the licensee was Thomas Woolley. The church of St John the Evangelist stands high in the background. Local legend indicates that a religious building was erected on the site of this church in the middle of the sixth century, and remains of a twelfth-century church are in evidence. The tower and spire are thirteenth century; alterations were undertaken in the fourteenth and fifteenth centuries.

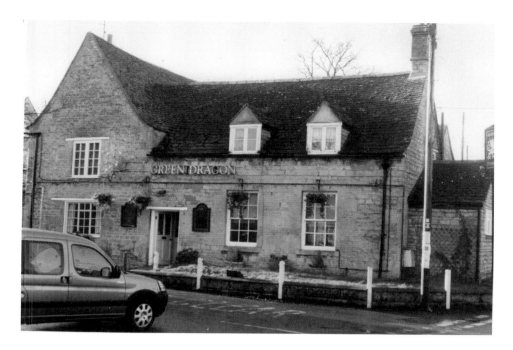

The Green Dragon

Above, the Green Dragon public house, standing in the market square at Ryhall, December 2005. Formerly this was the manor house, with a thirteenth-century vaulted cellar. In the eighteenth century it was converted into a farmhouse with a maltings producing and selling ale. In 1846, the landlord was William Sismore. John Gann held the inn by 1862. In 1891, Thomas Woolley was the landlord; he held the licence well into the twentieth century. Below, the Green Dragon public house in 1941. The landlord then was Reginald Bennett. In the far distance in this photograph is The Millstone Inn, the licensee of which was Horace Dearmer.

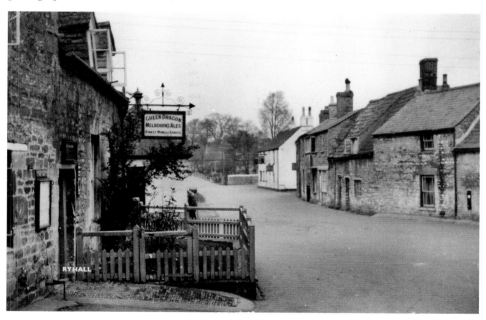

Great Casterton

The Crown Inn

The Crown Inn public house at Great Casterton, April 2006. This hostelry stands on the side of the original Great North Road, Ermine Street. It is considered to have become a hostelry in the seventeenth century. John Knight was the licensee in 1846; on his death in the 1890s his wife Eliza ran the business, and in 1904 their son John held the licence. During the First World War, George Michelson ran this public house. When hostilities ceased, this public house developed into a 'hostelry'. By 1925 William Lee was providing accommodation, refreshments and advertising rooms to let for cyclists and motorists. In 1936, William Wynn was offering the same service. On the outbreak of the Second World War this hostelry was partially closed, and in 1941 Amy Pattinson ran it as a public house.

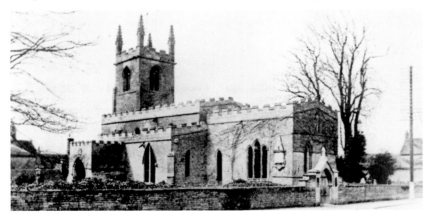

The Church of St Peter and St Paul

This photograph was taken in 1935, when the vicar was Revd Cecil Francis Norgate. This is a Norman church, and a reasonable amount of twelfth-century architecture has been retained. Thirteenth-century alterations have taken place, with a fourteenth-century tower, rebuilding and restoration. Noticeably it is a building that retains much of its medieval character.

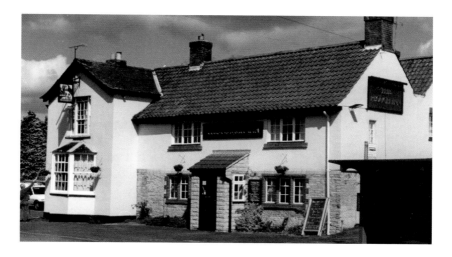

The Plough Inn

The Plough Inn public house, Main Street, Great Casterton, in April 2006. This building is situated near to the plan published below. In 1862, Mary Ann Smith was running a grocer's shop and providing assorted goods. She was also serving locally produced beer from her 'taproom'. From the 1870s until 1900 Abel Camm was running it as a public house. In 1904 until the outbreak of the First World War James Welch held the licence, and he was also running a painting and decorating business from this building. When war commenced, Thomas Bell ran the business. After the war, trade increased, and by 1925 John Farnworth was the publican. War came again, and in 1941 Clifford Blankley ran this pub on behalf of his father.

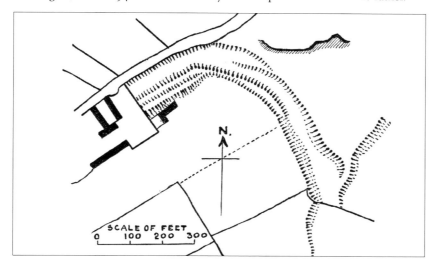

Roman Fort

This is a scale drawing published in 1908 of a Roman town, a *castrum* or Roman fort. Situated to the east of the village of Great Casterton, which can be viewed from the highway, there is clear evidence of a deep ditch and defensive rampart dating from AD 100. Continuous archaeological excavations have indicated occupation through to and including Saxon times, including finds of Anglo-Roman pottery. A visit to the Rutland County Museum to study this further is essential.

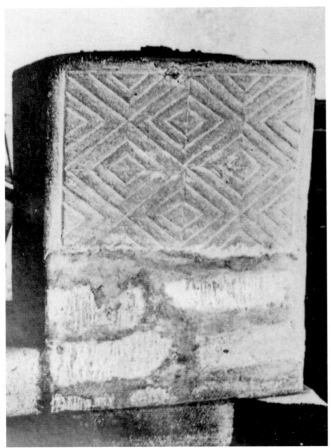

Left: Robert Grelley
A Norman font in the church of St Peter and St Paul, possibly erected at the expense of Robert Grelley in the early thirteenth century. Robert was a rebellious baron, at war with King Henry III. His estate was confiscated by the King and restored in 1217 – possibly he paid for the constructing of this font as penance. The stone is covered with incised diagonal lines in four panels.

Below: Woodhead Castle
A plan of Woodhead Castle, situated north-west of Stamford on high ground to the west of Great Casterton in 1908. It consists of a moat and the remains of a fortified castle. The first castle was possibly constructed around 1150 by Albert de Greste. His son Robert opposed King Henry III. Was the castle attacked by the King's army? The King made peace with him in 1217.

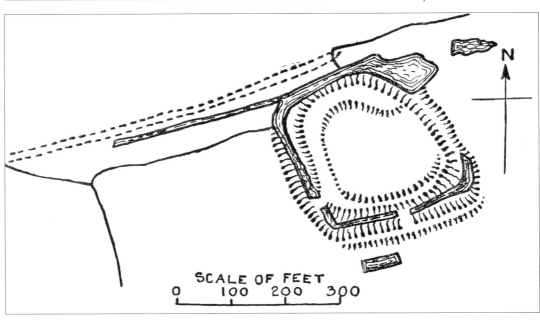

N

SCALE OF FEET
0 100 200 300

Little Casterton

All Saints Church

Little Casterton, a hamlet to the north of the town of Stamford on the River Gwash, with the small church of All Saints standing near the river. From the surviving evidence this is a Norman church, possibly built in the middle of the twelfth century and altered in the thirteenth century. Restoration took place in 1837.

Brooke

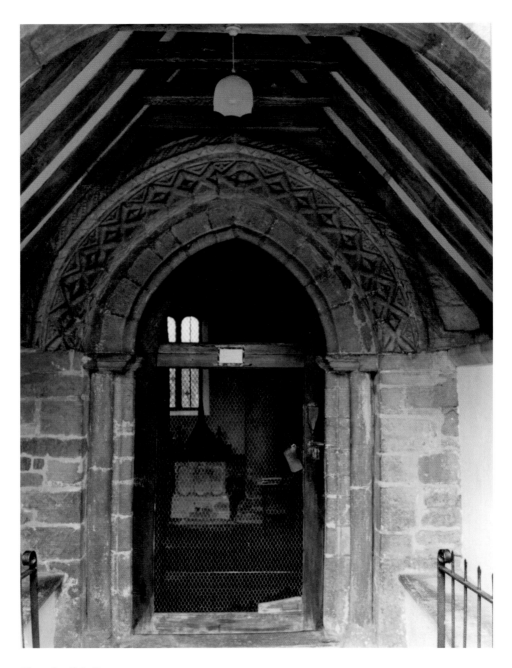

Church of St Peter
Fine Norman carving on the entrance to the church of St Peter, Brooke, constructed in the middle of the twelfth century.

Church of St Peter

Above, a drawing of the church of St Peter, Brooke, published when the vicar was the Revd Heneage Finch of Oakham church, All Saints, and assisted by three curates. Below, the Norman arch erected in the north aisle in the church of St Peter, Brooke; possibly this arch was rebuilt during the extensive restoration of 1580.

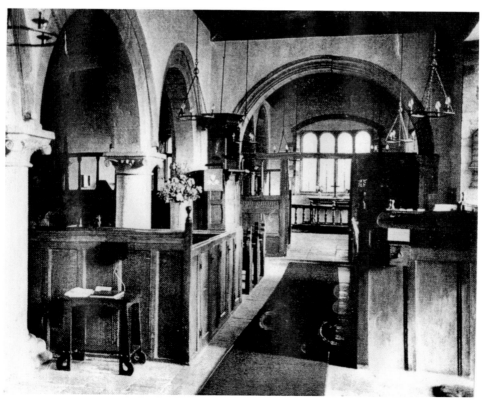

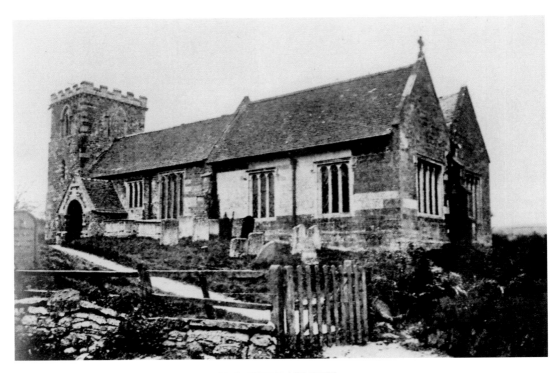

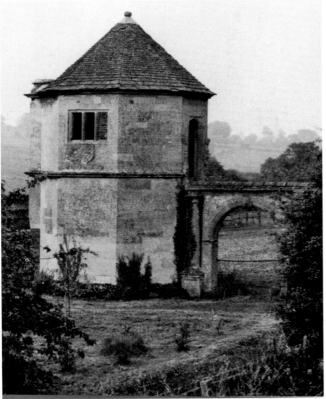

Above: **Church of St Peter**
The church of St Peter, Brooke, in 1935, when the vicar was Revd George Andrew Hassell. Compare it with the drawing printed on the previous page. Considerable alterations were undertaken by the Victorians in 1879; this would be when this small decorative cross was placed on the roof.

Left: **Brooke Priory**
The Augustinians formed a priory at Brooke in around 1150. It was demolished in 1549, and the Noel family purchased the site and constructed a large house near the remains of the priory. Most of this large house was subsequently demolished, and very little remains. This photograph, taken in the 1950s, shows the gatehouse, which for some time was used as a dovecote.

Edith Weston

The Market Cross
The Market Cross at Edith Weston, May 2006, standing in the centre of the village. Edith was the wife of King Edward the Confessor, 1042–66. The Normans built a Benedictine monastery in the village in 1114, which was dissolved in 1394.

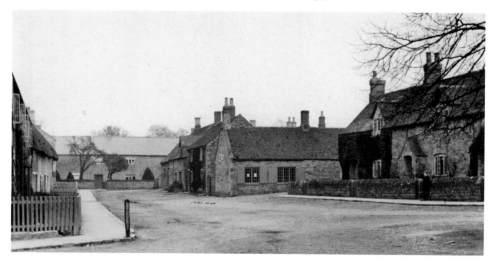

Village Square
The village square, *c.* 1920. The village weekly market was held in the centre of the village; produce was displayed around the Market Cross.

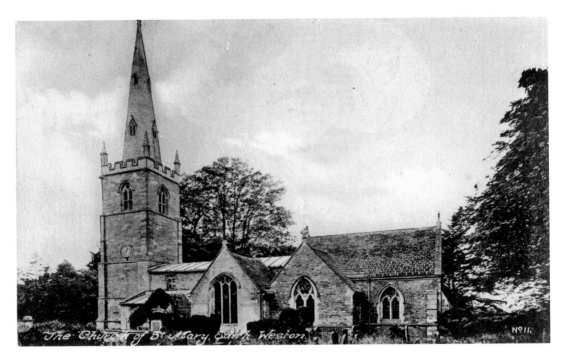

Church of St Mary

Above, the church of St Mary at Edith Weston in 1935. The vicar was the Revd Percy James Beaumont MA of Fitzwilliam College, Cambridge. This is a late twelfth-century Norman church, and alterations and additions to the building took place in the thirteenth, fourteenth, eighteenth and nineteenth centuries. Below, a photograph of the chancel of the church of St Mary, Edith Weston, looking east in 1935.

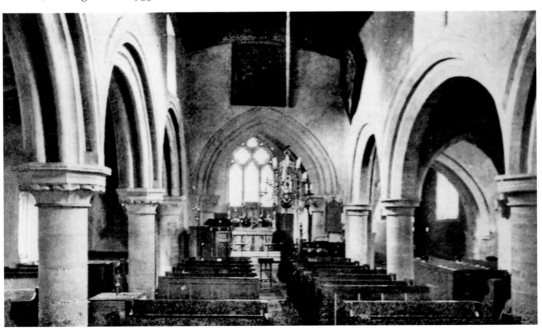

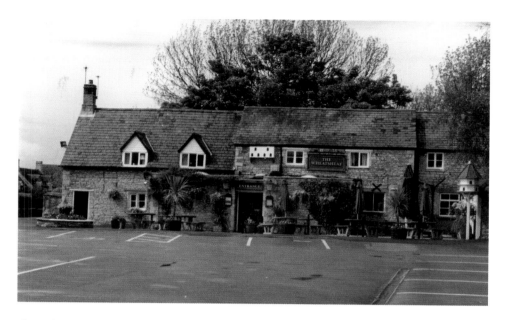

The Wheatsheaf

On the main road leading into the village of Edith Weston stands a historic public house: the Wheatsheaf, on No. 5 King Edward's Way, seen here in May 2006. In 1846 John Crowden was licensee, and on his death his wife Abigail ran this inn from 1862 to 1877. On her retirement in 1880, her daughter, Miss Mary Crowden, ran the licensed premises until just before the First World War. The licence was then passed to Joseph Bannister who was running the public house in 1916. In 1925, Arthur Stevenson held the licence. He passed it on to Herbert Cunningham in 1936, who was running the inn in 1941.

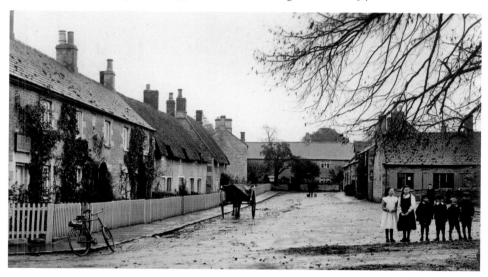

John Wilson Ball's Grocery and Bakery

A photograph taken in 1922. On the building to the left is the sign for John Wilson Ball's grocery and bakery. Near the Market Cross, children from the local school are lined up for the photographer. Miss Beatrice Hurrell was the headmistress.

Martingsthorpe

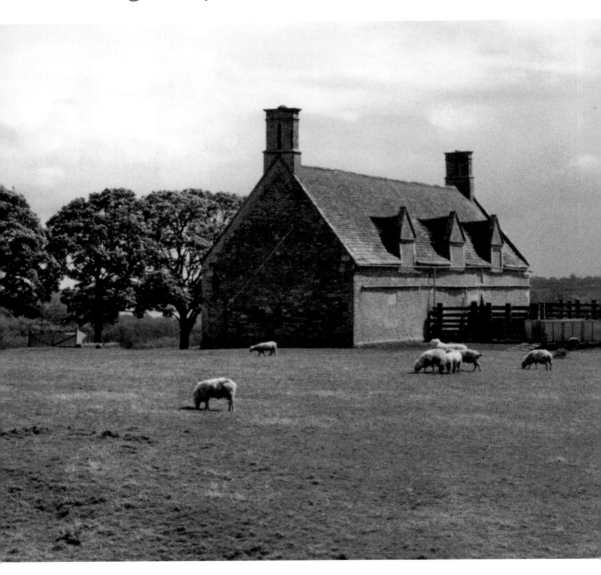

Old Hall Farm

The parish of Martingsthorpe consisted of two hamlets. A few houses of Gunthorpe are still located off the west bank of Rutland Water on the A6003 road. To the south of this hamlet is the deserted village of Martingsthorpe, and the earthworks can be located down a rough track. Standing near this track are the remains of the Old Hall Farm. This photograph was taken in May 2007. Near this building is the site of the medieval manor house, considered to have stood in the centre of a large collection of houses. By 1450 it was in ruins. The remains of a small village chapel that was demolished in the 1930s were also here. Now a thriving farm survives, created through being depopulated in the fifteenth century by the local landowner to raise large flocks of sheep.

Ketton

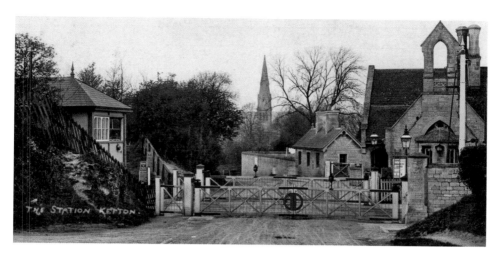

Ketton Railway Station
The crossing gate at the railway station in 1916, with the signal box to the left of the photograph. The stationmaster was Fred H. Stanley. Ketton railway station opened on 1 May 1848, became Ketton and Collyweston station on 8 July 1935, and closed on 6 June 1966.

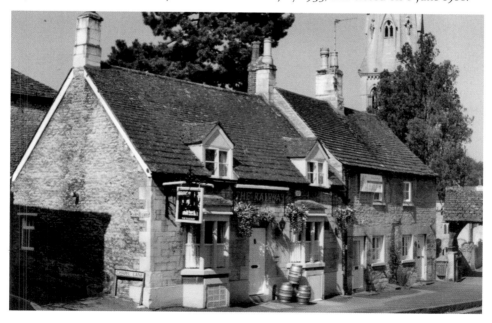

The Railway
The Railway public house on Church Street, Ketton, May 2006, located near the entrance to the church of St Mary, one of the finest churches in this area. This is a twelfth-century building, with some fine Norman architecture.

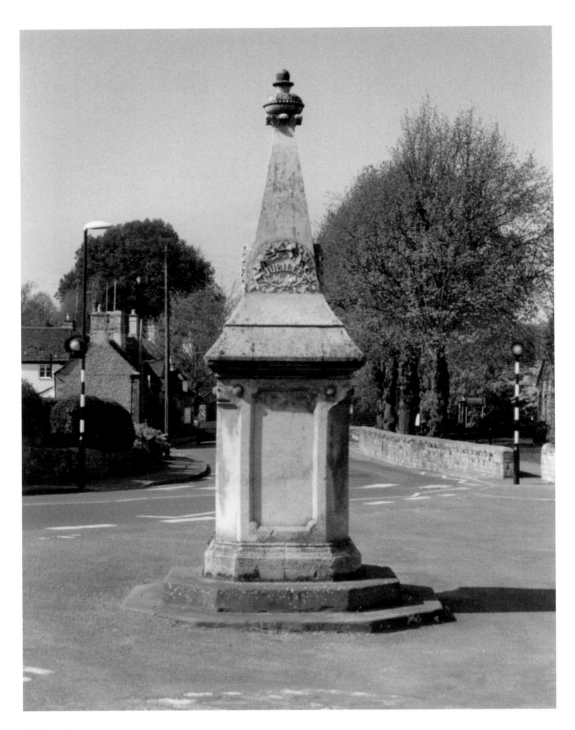

Market Square
The Queen Victoria memorial stone standing in the market square, Ketton. Possibly the first market was held in Ketton during the reign of King Henry I (1100–35). He gave England sound laws, providing a local form of income to the Bishop of Lincoln.

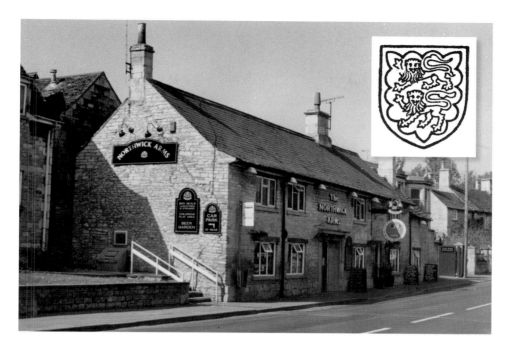

Northwick Arms

The Northwick Arms public house, High Street, Ketton, May 2006. John Rushout inherited part of the parish of Ketton in 1711, and was appointed as a baronet, taking on the coat of arms of Lord Northwick. This building became a beerhouse producing ale for the estate workers. By 1880 it was named the Northwick Arms, and the landlord was James Goodliffe. During the First World War, Mrs Eliza Sharpe ran this public house through to the early 1930s. William Dash held the licence until the beginning of the Second World War, and in 1940 George Kirk ran this pub. Inset, the Northwick Coat of Arms, sable, with two leopards in an engrailed border.

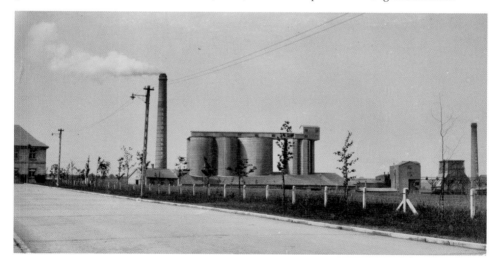

Ketton Portland Cement Works

Ketton Portland cement works in the 1940s. This company was formed in 1928 and the first kiln opened in 1929.

Lyndon

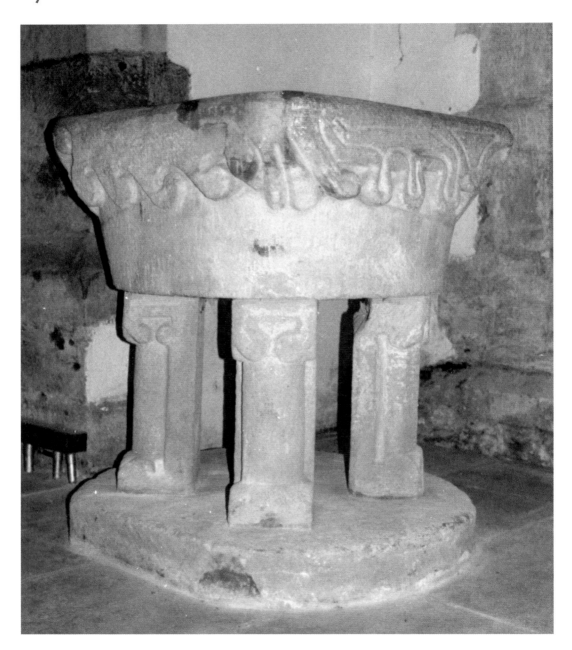

St Martin's Font
Lyndon is a hamlet to the south of Rutland Water, east of the A603 road. This is a photograph of the fine Norman font in the church of St Martin. A late thirteenth-century building, it was restored by the Victorians in 1866.

Manton

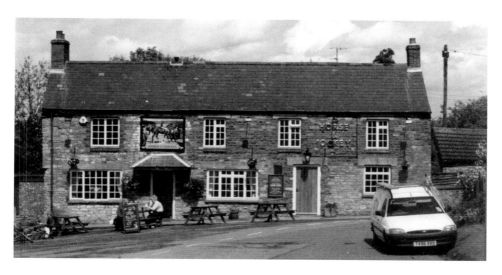

The Horse & Jockey
The Horse & Jockey public house, Manton, May 2006. This is a building steeped in history. One of the most notable licensees was John Clarke, who was running this hostelry in 1900.

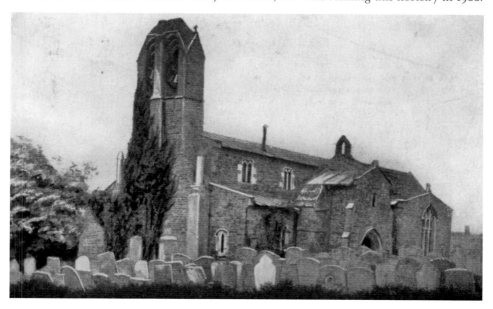

Church of St Mary
The church of St Mary at Manton in 1900. The vicar was Revd George Quirk MA. There is evidence that the church was extensively rebuilt at the end of the twelfth and the early part of the thirteenth century. In 1796, the chancel was partially demolished and rebuilt. This is an interesting building with a mixture of numerous styles.

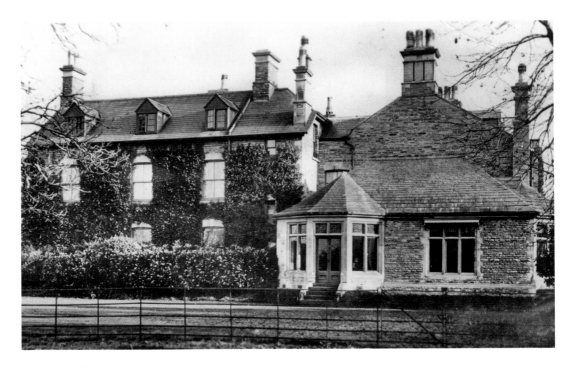

Manton Hall
Manton Hall, 1910, the home of Robert Heathcote JP.

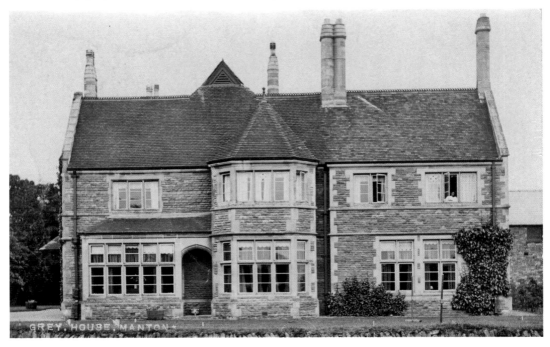

Grey House
Grey House, Manton, 1915, the home of Captain Edward Ralph Harbord.

26

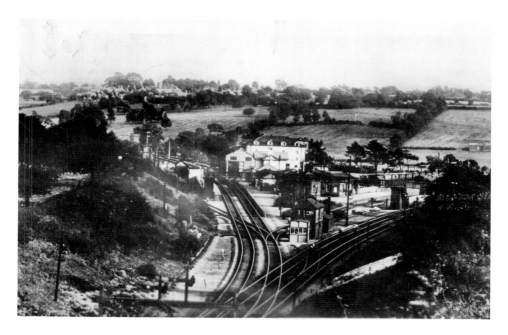

Manton Railway Station

Above, Manton railway station, 1910. The stationmaster was Henry Ernest Haines, and the station opened on 1 May 1848 as a part of the Midland Railway Company. This changed to the London, Midland & Scottish Railway on 1 October 1934. Below, Manton railway station, with the entrance to the tunnel in the background, seen here in the 1940s. The station was closed on 6 June 1966.

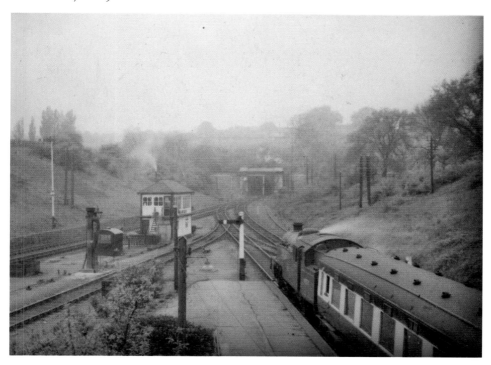

Normanton

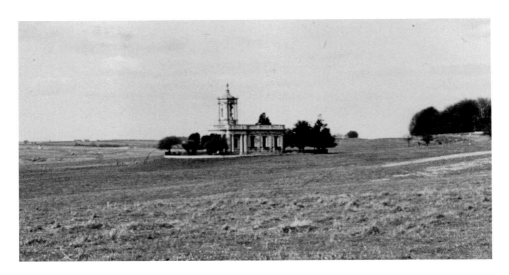

Church of St Matthew

Above, the church of St Matthew, Normanton, 1974. This church was constructed on the instruction of Gilbert Heathcote in 1764 on the site of a much earlier church. It was altered in the 1820s, and the nave was pulled down in 1911. In 1973 this all changed when the construction of Rutland Water commenced. This fine church stands well in the open fields. Below, the church of St Matthew has been converted into the Rutland Water Museum on the south bank of the reservoir. Partially filled with hardcore and concrete, in this photograph it stands majestically 'in the water'. A controversial decision: a surrounding 'tank wall' should have been constructed around the church!

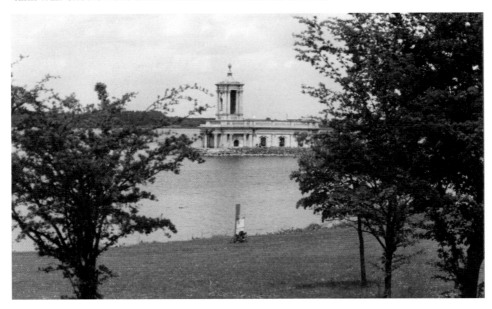

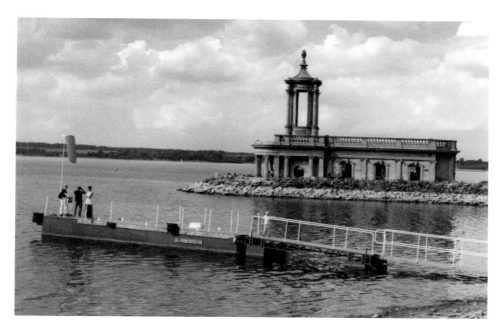

Rutland Water Museum
Rutland Water Museum in 2000, with passengers waiting for a boat to collect them from the pier after their visit to the museum.

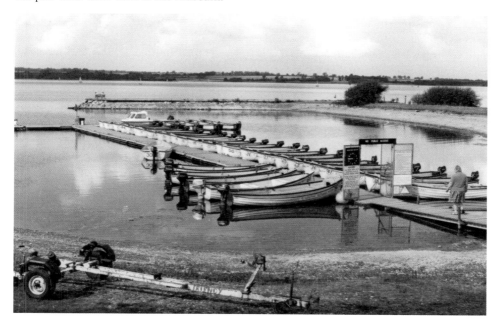

Normanton Reservoir
Fishing boats in the harbour on the south bank of the reservoir at Normanton. Rutland Water has developed into a major tourist attraction, involving fishing for trout and the world-famous nature reserve. It is now the centre of the Osprey Trust, where this famous fish-hunting bird breeds.

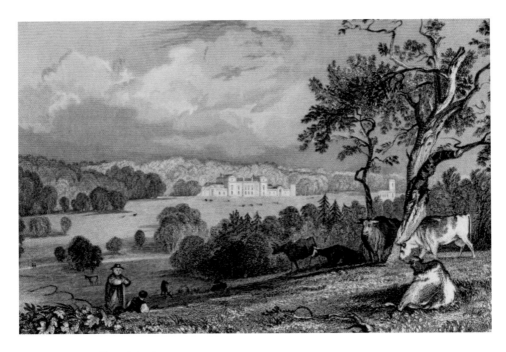

Normanton Hall and Park

Above, an engraving published in 1837 of Normanton Park with the hall in the background, drawn by T. Allom and engraved by D. Buckle. The small village that stood near the church featured in this engraving was swept away in 1764 when Gilbert Heathcote enlarged his park. Below, Normanton Hall in the park, 1900. This is the home of the right Hon. Earl of Ancaster PC, DL, and JP.

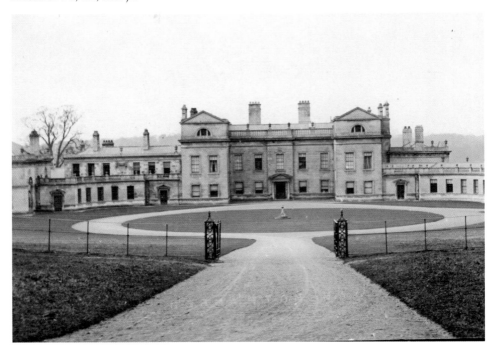

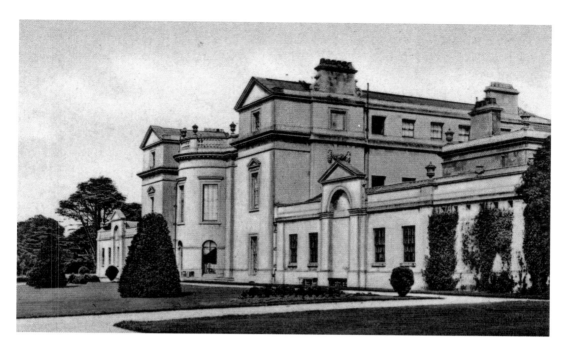

Normanton Hall

Above, Normanton Hall photographed in 1920, five years before it was demolished in 1925. Below, Normanton Hall stables, which have converted into a fine restaurant with accommodation, March 2013.

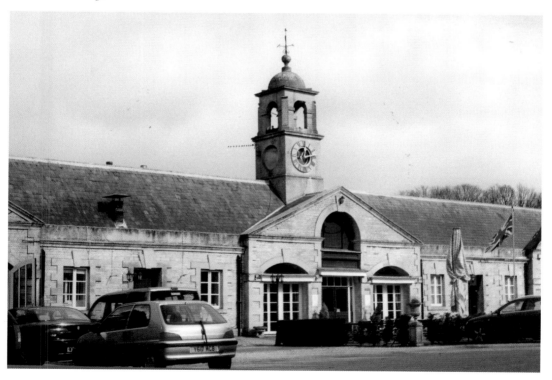

Tinwell

Left: All Saints Church
The entrance to All Saints church, with a protected swallows' nest, May 2006. This church stands on the north bank of the River Welland, principally a thirteenth- and fourteenth-century church, with fifteenth-century alterations. In the church are some interesting monuments, especially one to the Burghleys.

Inset: The Rutland Horse Shoe
A notable feature situated in the centre of Tinwell: 'the Rutland Horse Shoe', constructed as the entrance to a forge in 1880.

Below: The Crown
The Crown public house, Tinwell, May 2006.

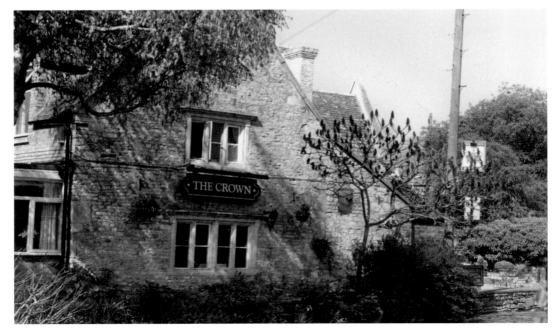

THE CROWN

North Luffenham

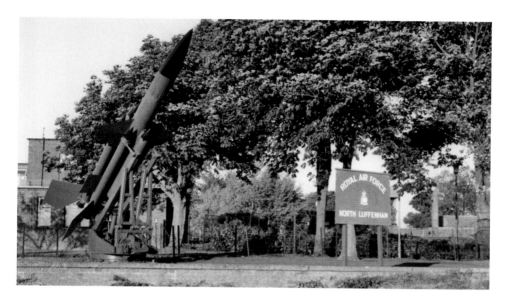

RAF North Luffenham
A surface-to-air missile standing outside the entrance to RAF North Luffenham in 1995.

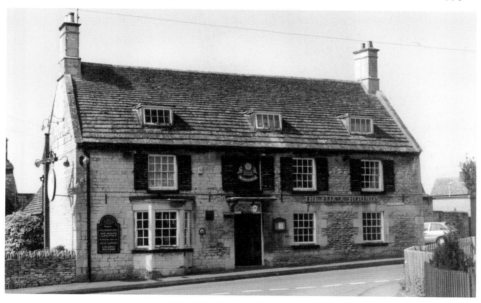

The Fox and Hounds
The Fox and Hounds public house, Pinfold Lane, North Luffenham, May 2006. This was situated down the road from the airfield, and thus well supported during the Second World War and the Cold War!

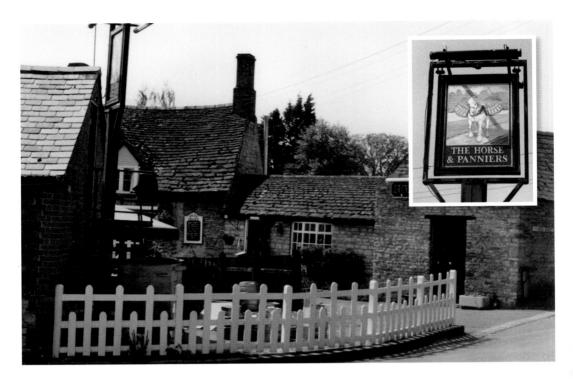

The Horse & Panniers

Above, the Horse & Panniers public house, Church Street, North Luffenham, May 2006. Inset, the sign of the Horse & Panniers. Below, the entrance to the Horse & Panniers Inn, 1904. The licensee was Richard Chapman, who was also the local baker, transporting bread around the lanes of Rutland by packhorse, and maintaining the tradition set by previous landlords who were also bakers.

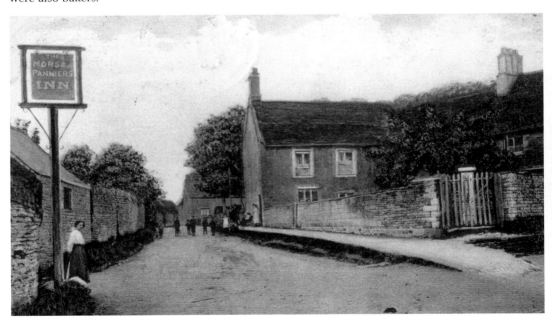

Two

Towards the Chater

The River Chater is a narrow river commencing from Leicestershire, below Whatborough Hill, to the east of Halstead. Entering Rutland from Launde Abbey Park, it meanders through some very fine countryside. With Manton to the north and Wing to the south, it passes between the two Luffenhams, 'North' and 'South', passing through Ketton in the Welland Valley. Ketton is a large village, separated into three districts: Aldgate and Geeston, south of the River Chater, with the main area of this village situated to the north of the stream. From Ketton, this narrow river joins the River Welland near Tinwell.

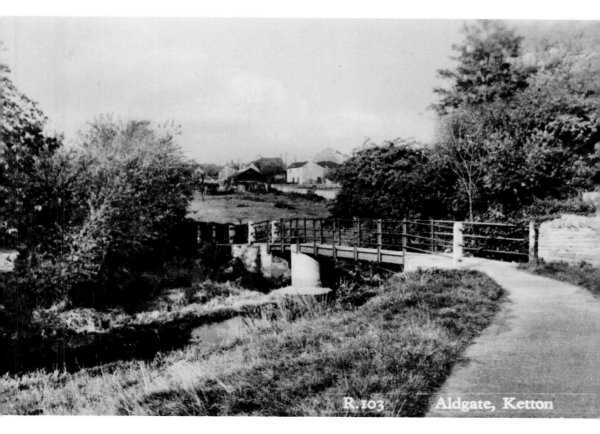

Bridge Over the River Chater
A photograph taken in the 1940s indicating the narrow bridge crossing the River Chater, with Ketton to the north, and the district of Aldgate to the south.

Ridlington

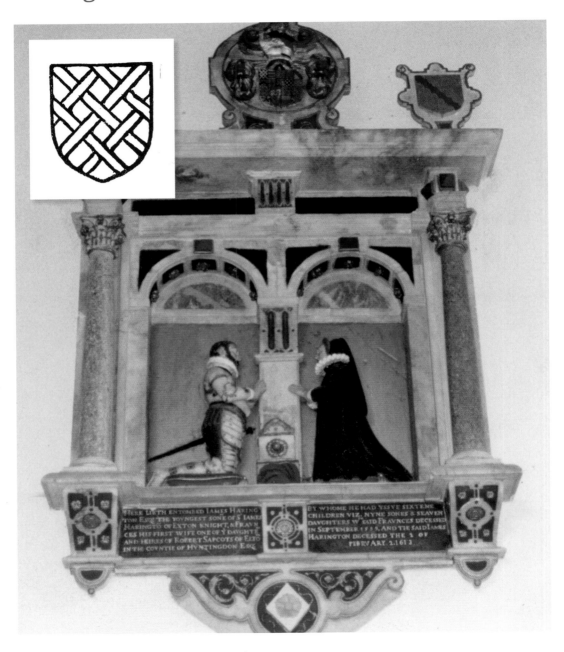

Church of St Mary Magdalene and St Andrew

A monument in the church of St Mary Magdalene and St Andrew, Ridlington. This was erected in 1613 to honour Sir James and Lady Harrington. Inset, the coat of arms of the Harringtons at Ridlington: '*Sable fretty argent.*'

Main Street, Ridlington

The Main Street of Ridlington in 1905, a small village to the west of the A6003 road north-west of Uppingham. This ancient village stands high on a windy ridge. To the west of the present village are a collection of earthworks, possibly from the Bronze Age, a hamlet long before the Roman occupation. This was an Anglo-Saxon village, owned by a Saxon queen in the seventh century.

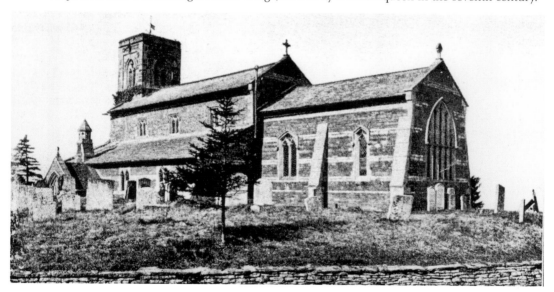

The Church of St Mary Magdalene and St Andrew, 1935

Certainly there was a Saxon church on this site. A tenth-century Norman tympanum has been well preserved, possibly rebuilt in the twelfth century. The church was altered in the thirteenth and fourteenth century. Unfortunately, the Victorians over-restored the whole building in 1860. In 1935 the vicar was Revd William Ashburner MA, in charge of this church at Ridlington.

Ayston

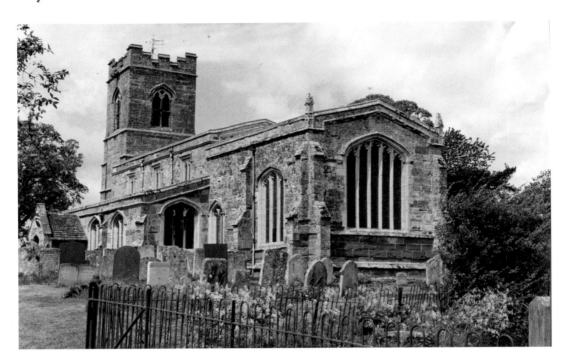

Church of St Mary the Virgin
Above, the church of St Mary the Virgin, Ayston, 2008. Below, the entrance to the hamlet of Ayston in 1925, situated on a hill north-west of Uppingham. In the background is the church of St Mary the Virgin, the vicar of which was Revd Thomas Randolph Allsopp.

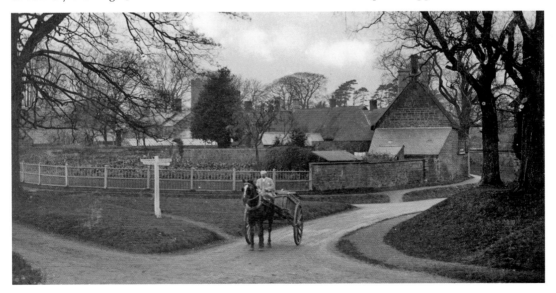

Barrowden

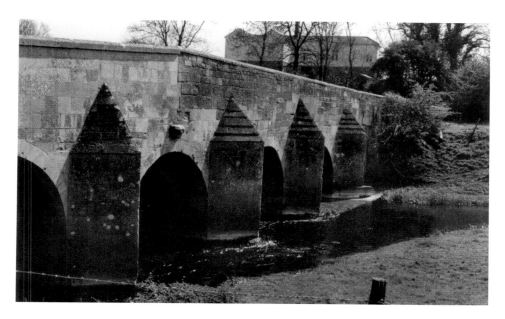

Wakerley Road and Bridge

Above, Wakerley Bridge, Barrowden, 2008, constructed in the 1350s. This was a packhorse bridge intended to allow the packhorse trade to the market granted in 1349 by Edward III. The bridge was widened in 1793, maintenance being maintained by two counties: Rutland and Northamptonshire. In this photograph, the smooth stone indicates Rutland to the north and the rough stone of Northamptonshire to the south. The county boundary is in the middle of the River Welland. The village of Wakerley sits high in the background. Below, Wakerley Road, leading out of Barrowden in the 1940s to the packhorse bridge.

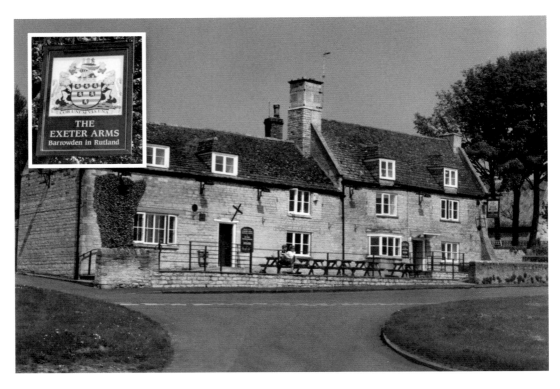

The Exeter Arms

Above, The Exeter Arms public house, Main Street, Barrowden, May 2006. Below, the village green at Barrowden in the late 1940s with the duck pond to the left; on the right is The Exeter Arms.

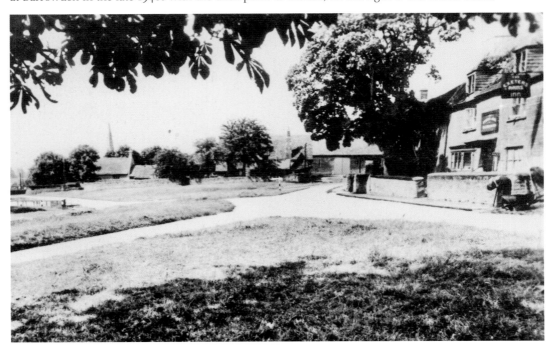

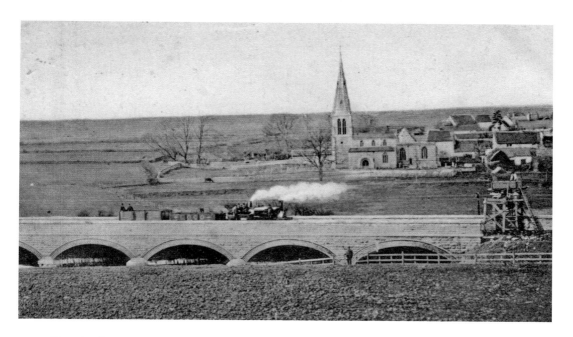

Church of St Peter

A photograph taken in Northamptonshire of the church of St Peter in the village of Barrowden; the vicar was Revd Arthur Edward Hutchings. In the foreground, a goods train is travelling along the London & North Western Railway to Wakerley and Barrowden station, which opened on 1 November 1879 and closed on 6 June 1966.

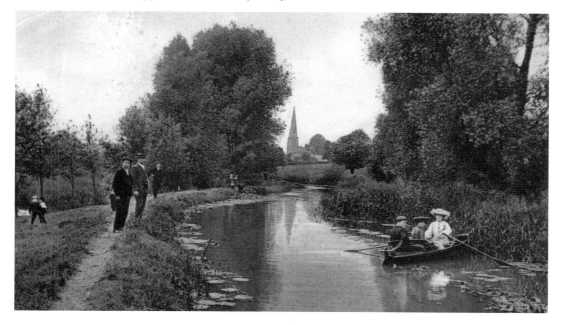

The River Welland

Boating on the River Welland south of the village of Barrowden in 1904. High in the background is the church of St Peter.

Belton-in-Rutland

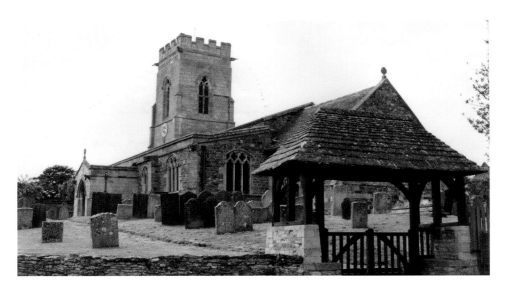

Church of St Peter
The church of St Peter, Belton-in-Rutland, 2006. Possibly built at the end of the twelfth century, much of the building is of the fourteenth through to the sixteenth century. Extensive restoration took place in the Victorian period 1897–98, and some of the medieval architecture was lost.

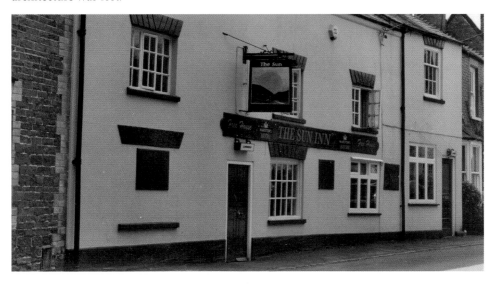

The Sun Inn
The Sun Inn public house, No. 24 Main Street, Belton-in-Rutland, June 2006. This is a sixteenth-century building converted into a public house over 250 years ago. Originally it was a wheelwright's workshop.

Bisbrooke

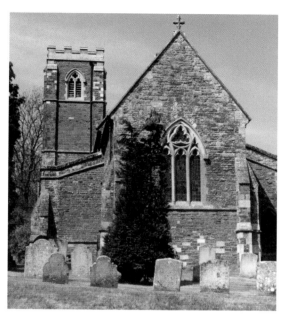

Right: **Church of St John the Baptist**
The church of St John the Baptist, 2006, built in 1871. Two previous buildings stood on this site: a Saxon church and a medieval thirteenth-century building that was demolished by the Victorians.

Below: **The Gate Inn**
The Gate Inn public house, Main Street, Bisbrooke, May 2006, which stands on a low hill just outside the village.

Caldecott

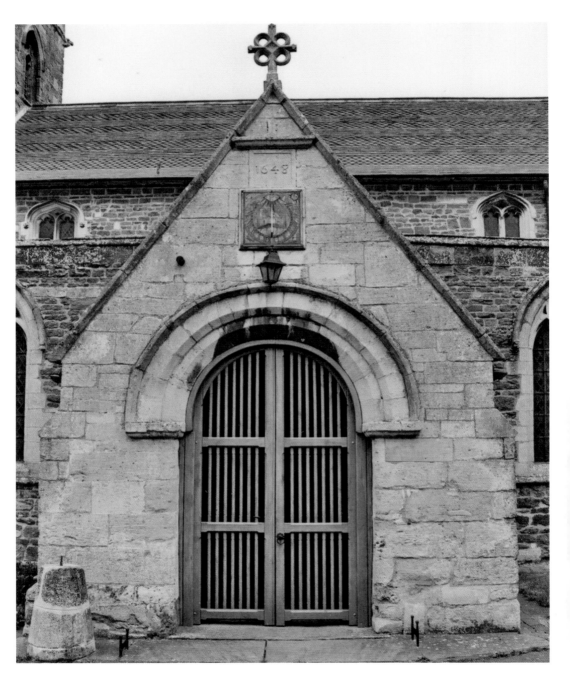

Church of St John the Evangelist
A photograph of the church porch, dated 1648, the church of St John the Evangelist, 2008.

Right: **The Church of St John, Caldecott**
In 1926 the vicar was Revd Henry Brooke Brown, MA. This is a twelfth-century Norman church with a pleasant window that has been retained. A considerable amount of thirteenth-century and seventeenth-century work is visible. Alterations have taken place in the seventeenth, nineteenth and twentieth centuries.

Below: **Caldecott Village Green**
The village green at Caldecott during the First World War.

Glaston

Church of St Andrew

Above, the church of St Andrew, Glaston, 2006. A twelfth-century building, very little of the Norman architecture remains. Considerable alterations took place in the sixteenth century. Between the years 1862 and 1864 the Victorians made many changes to the interior of this church. Below, a view of the church of St Andrew, which is just visible through the trees, in 1936. On the left is the rectory, the home of the vicar Revd John Henry Woods, MA.

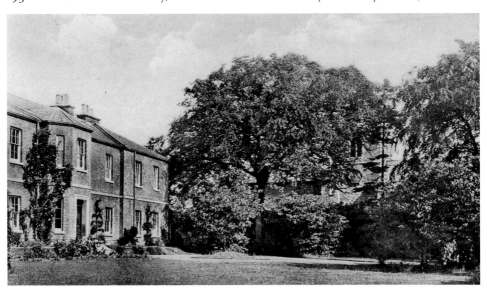

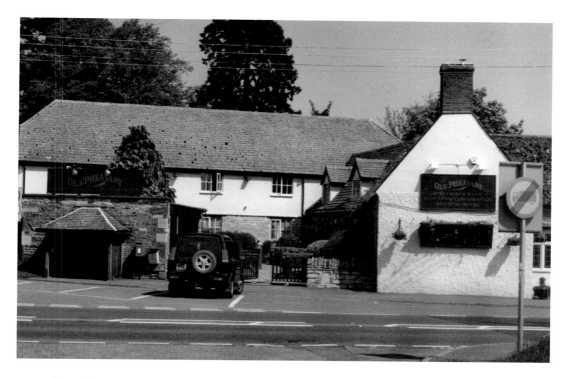

The Old Pheasant
The Old Pheasant public house, No. 15 Main Road, Glaston, May 2006.

Main Road, Glaston
The Main Road, Glaston, in 1936; now the A47 looking west. To the right is where the Old Pheasant public house is now situated.

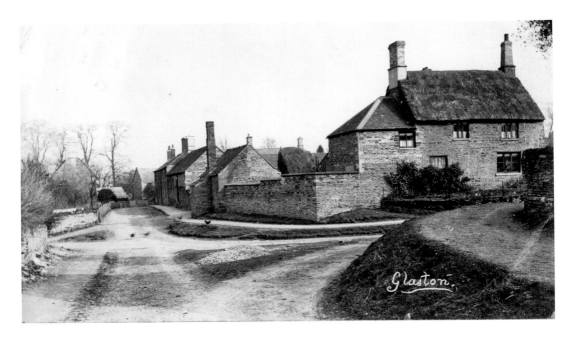

Main Road, Glaston
Hens crossing the Main Road in Glaston, which leads into Church Street, 1905.

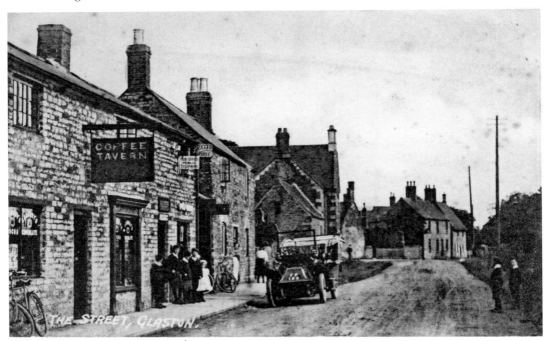

The Coffee Tavern
The Coffee Tavern situated next to the post office in Glaston, 1905. Drivers of cars passing through this village before the First World War stopped for refreshments in the Tavern! The post office was run by Mrs Elizabeth Warren, sub-postmistress.

South Luffenham

Right: **South Luffenham Windmill**
The gutted shell of the windmill in the fields south of South Luffenham, May 2006. This tower mill was built in 1832 to be used by the families of Tilley and Molesworth. By 1895 the sails had been removed and the mill was converted to steam. In 1900 it ceased to work. Over the following years all of the mechanism was stripped out and sold, and it is now a picturesque ruin.

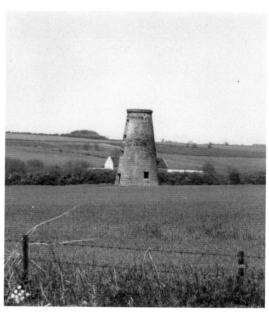

Below: **The Coach House Inn**
On the outskirts of the village of South Luffenham on the A6121 road stands the Coach House Inn, a public house, at No. 3 Stamford Road, May 2006. This was constructed on the important road leading into Stamford to cater for the coaching trade in the eighteenth century. Inset, the sign of the inn with the Ostler's restaurant.

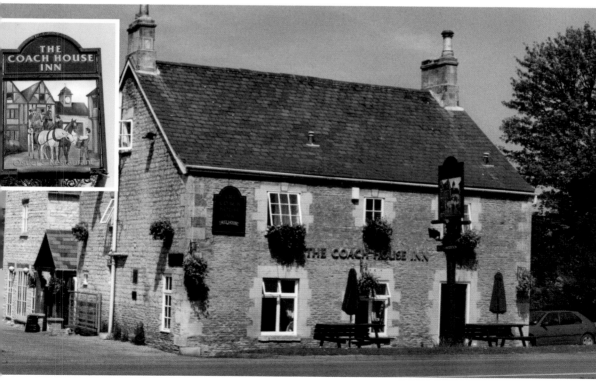

The Boot & Shoe

The sign of the Boot & Shoe public house, hanging in the Street, South Luffenham, May 2006. Below, the village centre, 1925. The Boot & Shoe Inn is on the left; the landlord of which was John Arthur Hunt. To the right is Mrs Sarah Elizabeth Chapman's shop and in the middle-distance stands the church of St Mary, the vicar of which was Revd John Francis Richards, MA.

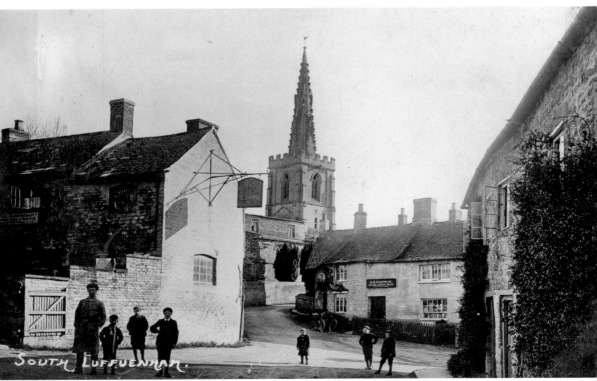

Lyddington

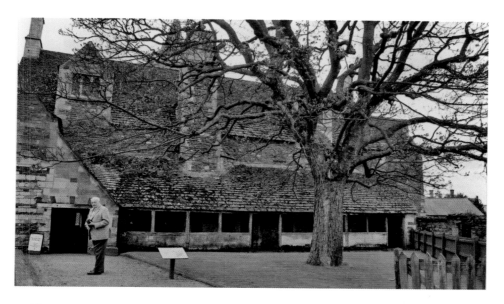

Lyddington Bede House

Above, the author at Lyddington Bede House, April 2006, originally built as a medieval bishop's palace between 1480 and 1514. As a result of the Dissolution in 1547, in 1602 it was converted into almshouses for twelve poor men, two women and a warden. It is now under the protection of English Heritage. Below, Lyddington Bede House, April 2008.

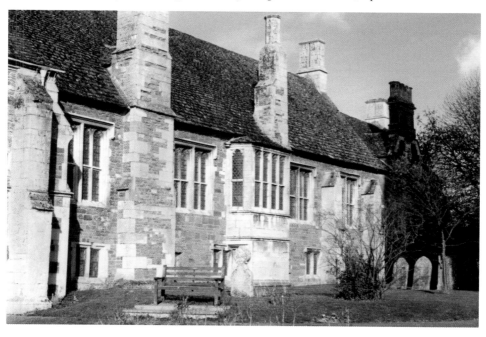

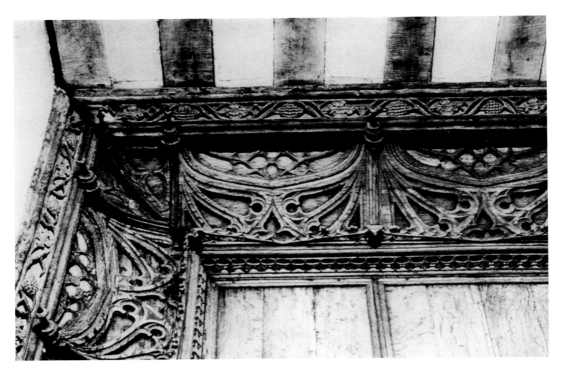

Bede House Interior
Above, the decorative carving in the ceiling at Lyddington Bede House. Below, a fine view of the main room in Lyddington Bede House.

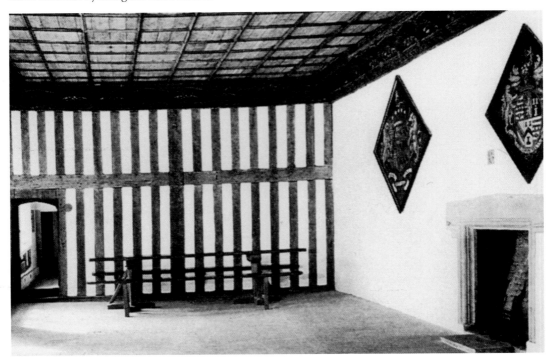

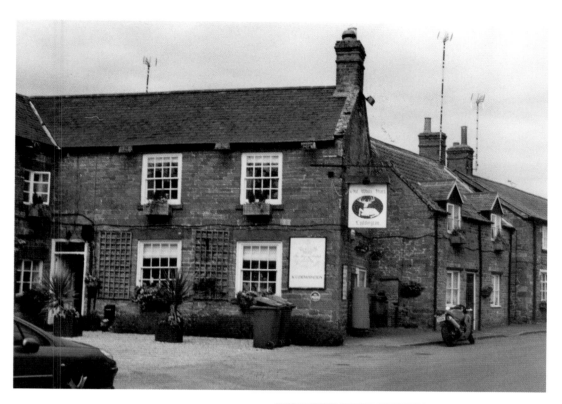

Above: **The Old White Hart**
The Old White Hart public house, just south of the entrance to Lyddington Bede House, No. 51 Main Street, April 2006.

Right: **Watchtower**
The polygonal watchtower, part of the Bishop's Palace complex, 1916. The church of St Andrew stands in the background. The vicar was Revd Spencer Richards Pocock, King's Councillor.

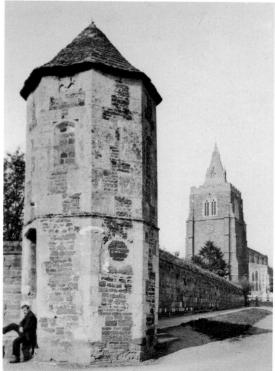

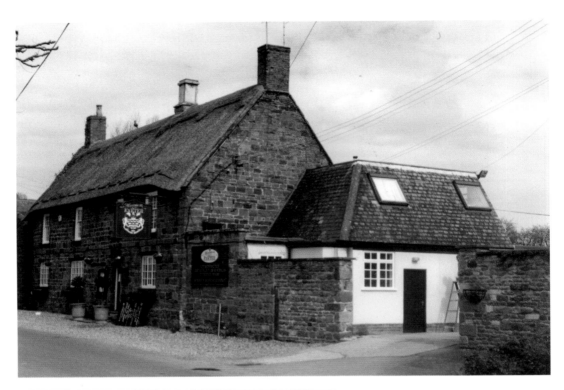

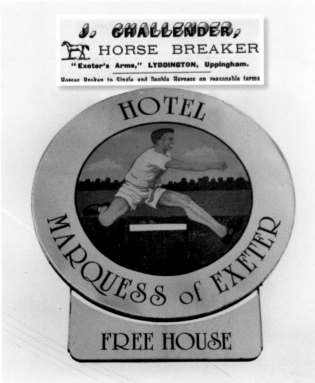

The Marquess of Exeter
The Marquess of Exeter, a sixteenth-century hostelry, No. 52 Main Street, Lyddington, in April 2006. To the left, the sign of the Marquess of Exeter in 1995, featuring David, Lord Burghley, 6th Marquess of Exeter, who was an international hurdler between the years 1924 and 1933. At the 1928 Olympic Games he won the gold medal, followed by a silver medal in 1932. Inset, an advertisement for John Challender's horse-breaking business, 1909. He was also the landlord of the Marquess of Exeter.

Morcott

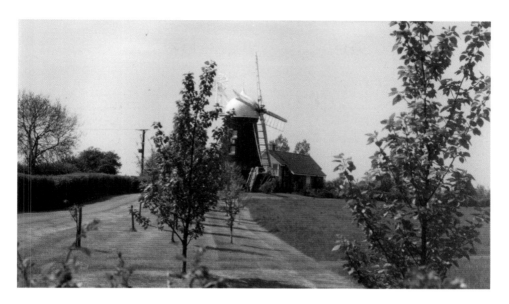

Morcott Windmill
This restored windmill stands to the south-east of the village of Morcott, May 2006. Originally built around 1820, in 1921 it was partially demolished by explosives. This building was purchased in 1968, restored, and now stands well in the landscape. It is not open to the public.

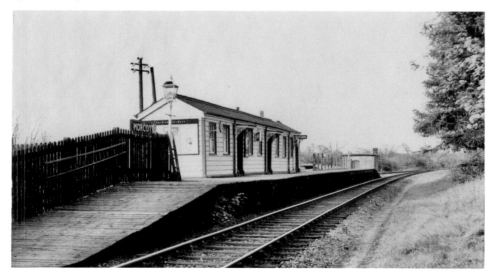

Morcott Railway Station
The Morcott railway station, *c.* 1945. This London & North Western railway station was opened on 1 December 1898 and closed on 6 June 1966.

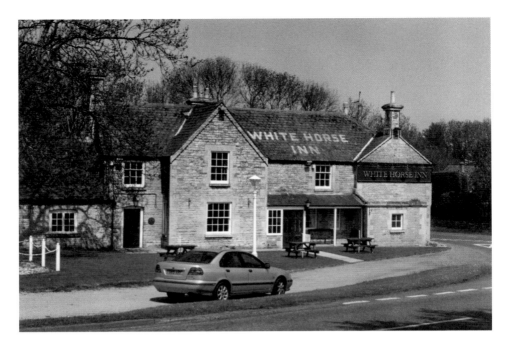

White Horse Inn
The White Horse Inn, Morcott, May 2006. This is an interesting public house situated on the junction of the A47 and A6121 roads. It was constructed on the Stamford Road to serve the coaching trade in the eighteenth century.

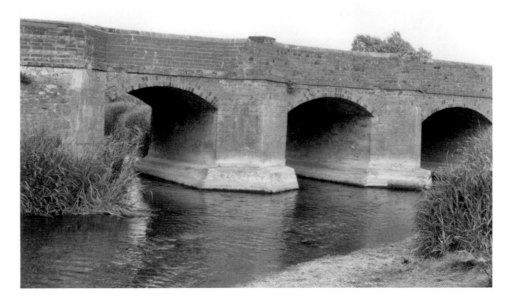

Packhorse Bridge
The restored packhorse bridge, constructed on the bridleway that crosses the River Welland south of Morcott, allowed trade into Northamptonshire when horses were more important than coaches, cars and lorries.

Pilton

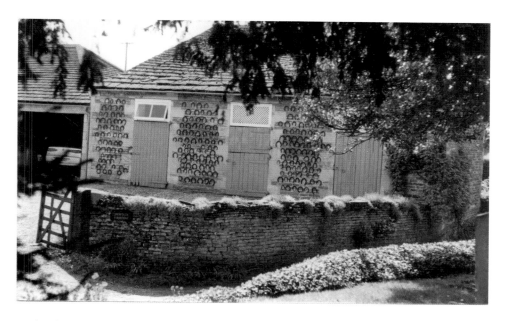

Rutland Horseshoes

Above, an arranged display of horseshoes attached to the walls of the stable in 2006, viewed from the grounds of the church of St Nicholas. This is a small thirteenth-century building that was considerably restored in 1852. Below, the display of Rutland horseshoes on the wall of the stables opposite the church of St Nicholas, 1995.

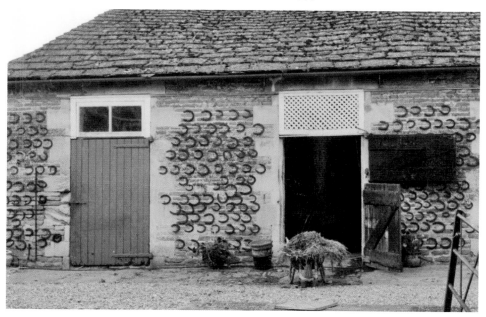

Preston

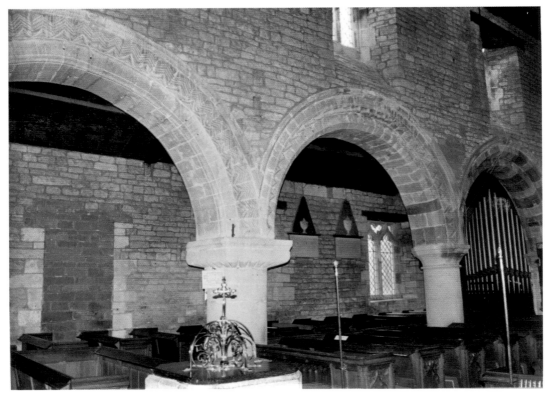

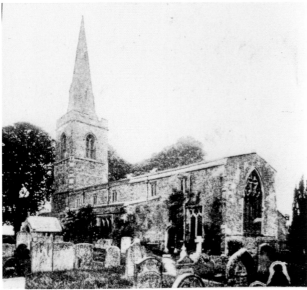

Church of St Peter and St Paul
Above, the Norman arches in
the church of St Peter and
St Paul, Preston. This is a Norman
church built on the site of a Saxon
building, possibly during the early
part of twelfth century. Major
rebuilding took place during
the early part of the thirteenth
century, and the Victorians
organised a major restoration
programme in 1856. To the left,
the church of St Peter and St Paul,
Preston, 1936. The vicar was the
Revd Horace Fassell, MA.

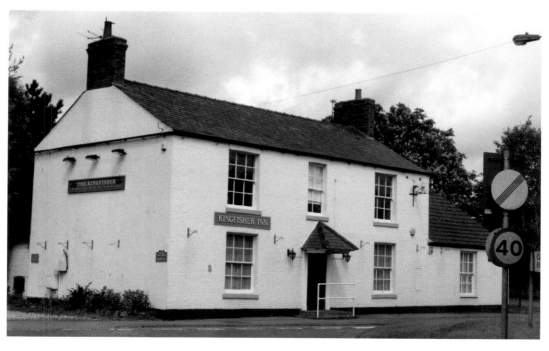

Kingfisher Inn

Above, the Kingfisher Inn public house, Uppingham Road, Preston, May 2006. Below, the Kingfisher Inn, March 2013. No longer a public house, it is scheduled for demolition.

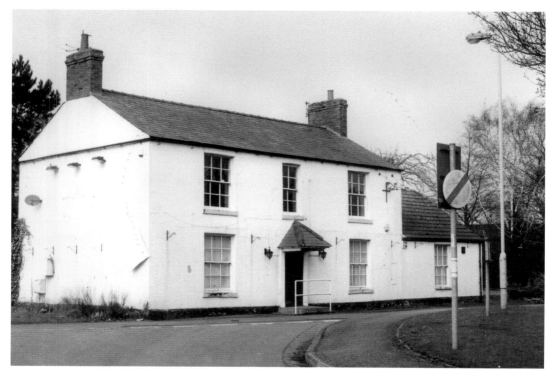

Seaton

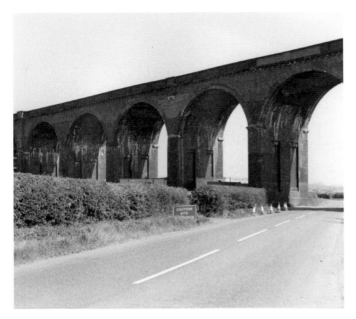

Left: **Welland Viaduct**
When any person is approaching the village of Seaton they must be overawed by the magnificent Welland Viaduct, which crosses the valley. Built in 1876–78 with eighty-two brick arches, it is three quarters of a mile long and crosses the B672 road.

Below: **George & Dragon**
The George & Dragon public house, No. 2 Main Street, Seaton, May 2006. Inset, the sign of the George & Dragon.

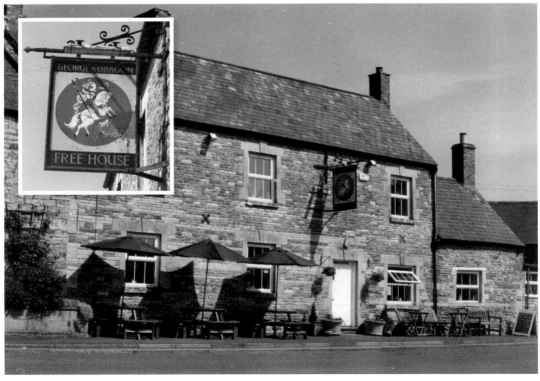

Stoke Dry

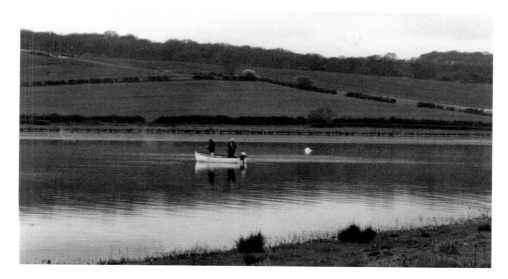

Eyebrook Reservoir

Above, Eyebrook Reservoir is situated to the south of the county of Rutland. This picture was taken on the east bank of the reservoir 2008. The B664 road is to the north, and the B672 road to the south, linking with the A6003 road to the east. Eye Brook rises out of the southern ridge of Tilton-on-the-Hill, draining through the countryside to the River Welland to Caldecott. The reservoir was completed in 1940 to supply water to the ironworks in Corby. Now it is a haven for wildlife, with lay-bys having been erected off the highway. Fishing for trout on this reservoir is highly recommended. Below, fishing for trout off the Rutland bank of Eyebrook Reservoir, May 2006. In the 1940s this valley echoed to the noise of Lancaster bombers practicing for the Dambuster raid.

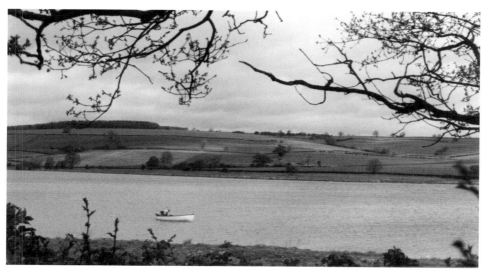

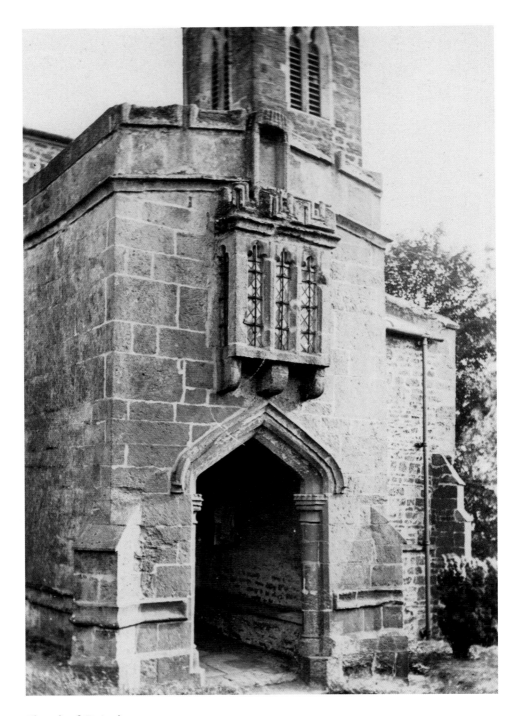

Church of St Andrew

The entrance to the late Tudor north porch of the church of St Andrew. Over this porch is a small priest's room. Local legend has it that Sir Everard Digby, who lived at Stoke Dry, hatched the Gunpowder Plot with Guy Fawkes in this small room. They were hanged, drawn and quartered in 1606.

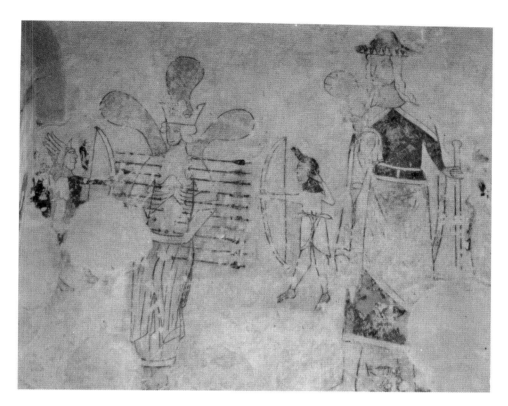

Church of St Andrew

Above, a thirteenth-century wall painting retained in the church of St Andrew, Stoke Dry. This is a painting of the crucifixion of St Andrew, executed with arrows, *c.* 1250. Below, the church of St Andrew, Stoke Dry, 1936; a small Norman church with some splendid stone carvings that have been dated to approximately 1120. For ten centuries this splendid church has been well maintained, retaining its place in history.

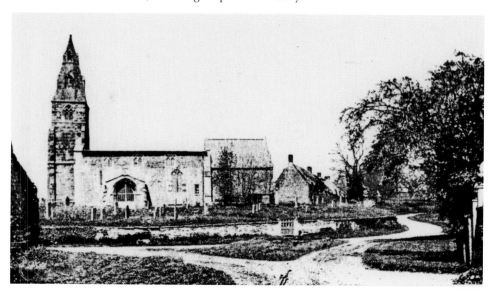

Thorpe-by-Water

Thorpe Watermill

Above, a field road leading into Thorpe-by-Water, across the bridge over the disused branch line of the London & North Western Railway, May 2006. This hamlet, off the B672 road close to the River Welland, is a beautiful site, overlooking the river valley and containing some very interesting sixteenth-, seventeenth- and eighteenth-century yeoman houses. There was a watermill on the river. It was possibly created as a separate manor from Seaton in 1615. There was a watermill at Thorpe before 1615, when this small area of land was part of the manor of Down Hall. This parcel of land was obtained from John Osborne as a separate manor by Edmund Clipsham and his wife to create an income for two of his sons, Edmund and Michael. A powerful overshoot watermill was in use. The drawing below illustrates how it functioned. This mill created considerable income through producing flour. This small manor had possibly developed as a hamlet from the manor at Seaton by 1772.

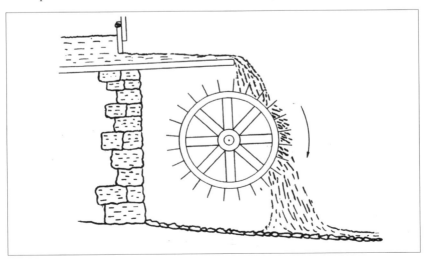

Tixover

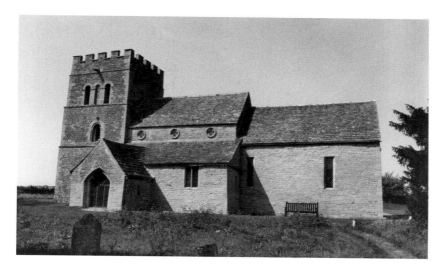

Church of St Mary Magdalene

Above, the church of St Mary Magdalene 'in the fields', near Tixover, May 2006. This church is dominated by an impressive Norman tower, dating from 1130. It is a twelfth-century church incorporating Norman architecture, extensively rebuilt in the early part of the thirteenth century. Restoration of the building took place in the early part of the seventeenth century. The Victorians undertook some alteration to the clerestory windows. There are extensive remains of an early village near this church, and the remains of a Roman bridge that crossed the River Welland were discovered. Below, a plan produced in 1936 of the Norman church, isolated in the fields, outside Tixover. The vicar, Revd Percy Nichols, MA, lived at nearby Duddinton.

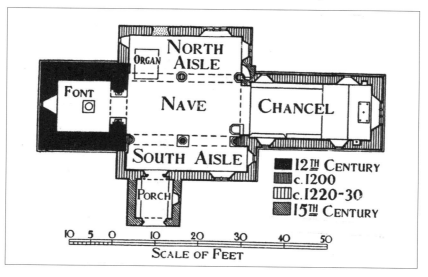

Wardley

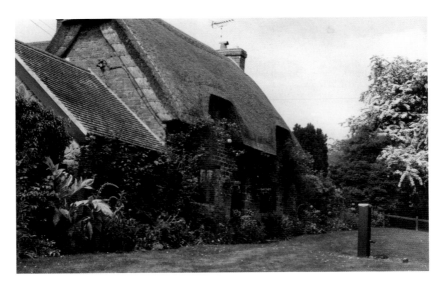

Wardley Village Pump
The village pump on the Green at Wardley, June 2006. Wardley is a hamlet off the A47 road to the west of Uppingham on the Leicestershire border. To the south-east of this hamlet is Wardley Wood, Forestry Commission access land with a field footpath passing through the centre of the wood from Castle Hill to Eyebrook.

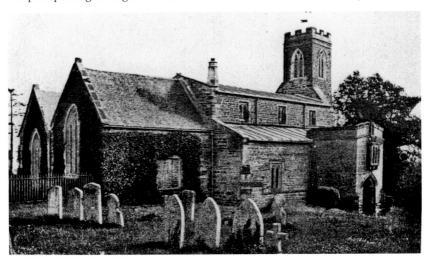

Church of St Botolph, 1936
The vicar was Revd David Evans, BA. There was a Saxon church in the village of Wardley. Part of the present church is clearly Norman, possibly built towards the end of the twelfth century. There are restorations dating from the thirteenth, fifteenth and eighteenth centuries, and major rebuilding took place in 1871.

Wing

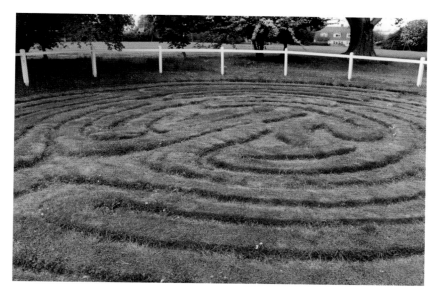

Medieval Maze

At Wing on the minor road to the village of Glaston is this medieval maze. It is not possible to date its construction and purpose, although it is possibly early Norman, with religious significance, as similar designs exist in Norman churches in France.

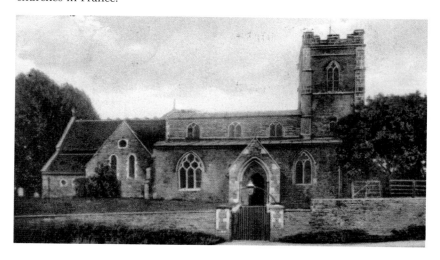

Church of St Peter and St Paul, 1905

The vicar was Revd Richard White, MA. This is a Norman church with some twelfth-century remains, especially the south arcade of c. 1150. For ten years, from 1875 to 1885, the Victorians demolished and rebuilt most of the building, losing its medieval heritage.

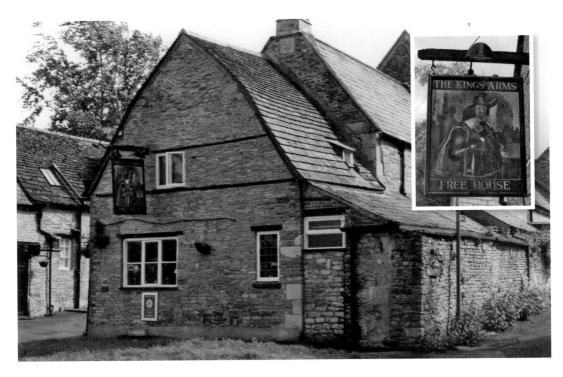

The King's Arms
The King's Arms public house, Top Street, Wing, May 2006.

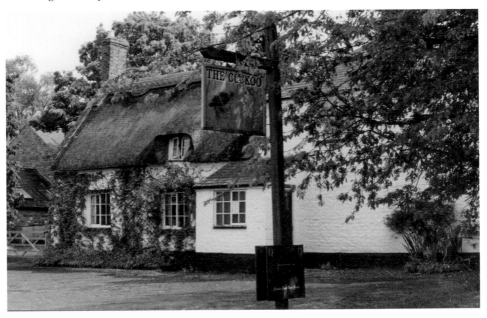

The Cuckoo
The Cuckoo public house, Wing, May 2006. This building has now been converted into a private house.

THREE

Uppingham Town

Uppingham is a small market town off the A47 road, with the A6003 road passing through the centre of the town. In 1584, Archdeacon Johnson founded Uppingham School, and now it is an integral part of this small town, with boarding houses part of an involved complex. The art school, library and separate classrooms are part of this famous public school, and blend into the seventeenth-century town landscape. The market was granted by Edward I in 1281 and still operates every Friday. On the market square stands the fine public house, the Vaults; opposite is the Falcon Hotel, basically a seventeenth-century building. East along the High Street is the seventeenth-century building the Crown Hotel, and in the yard at the rear the stables have been converted into an antique centre. On Orange Street is an internationally recognised art gallery, specialising in modern art. In the centre of the town there are some interesting bookshops, at least three specialising in fine second-hand books and prints. Shopping in this small town is a pleasure, especially on market day. Stay awhile and enjoy the hospitality of some excellent restaurants.

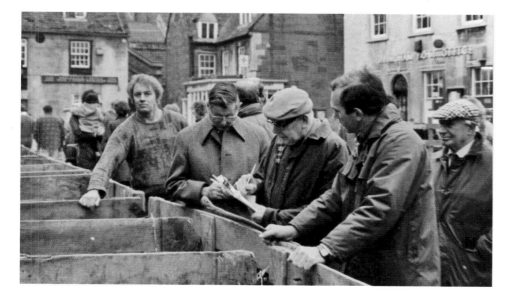

Fatstock
An auctioneer selling pigs at the annual Fatstock show that takes place in November in the Market Place at Uppingham, seen here in 1995. This cattle market could date back to the thirteenth century.

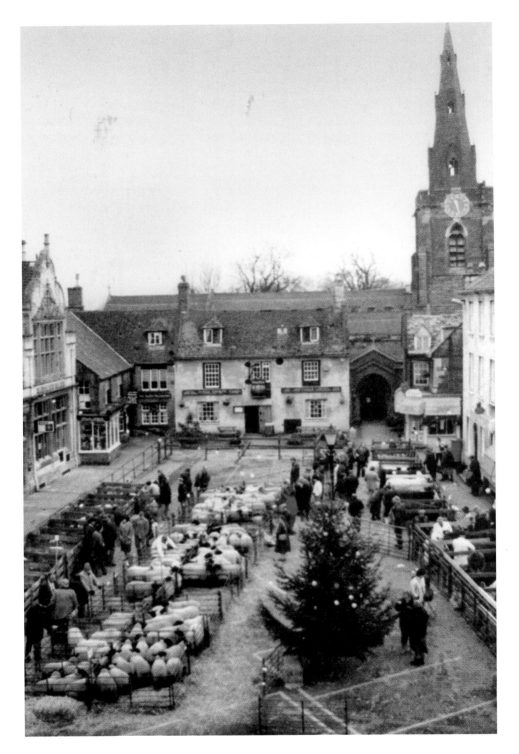

Fatstock
The annual Christmas Fatstock show in front of the Vaults in the Market Place, Uppingham, 1999.

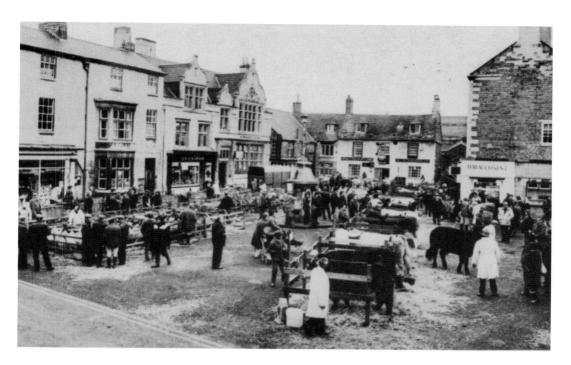

Fatstock
The annual Fatstock show being held in November 1966 in the market square, Uppingham.

The Vaults
The Vaults public house in the market square, Uppingham, April 2006.

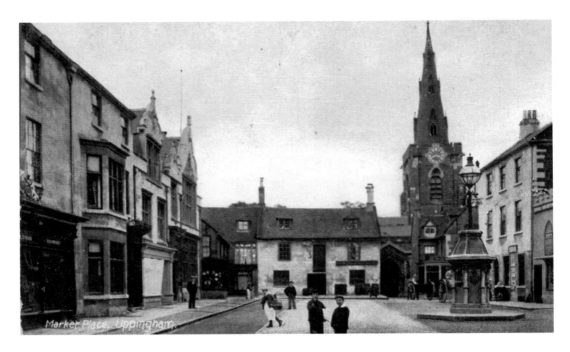

Church of St Peter and St Paul

Above, the market square at Uppingham, *c.* 1910, with the church of St Peter and Paul high in the background. The Vaults dominates the square. Below, the chancel of the church of St Peter and St Paul, 1916. The vicar is the Venerable Edward Malsham Moore, MA. Unquestionably, an Anglo-Saxon church would have stood on this site. There is evidence of Norman architecture, and the tower is fourteenth century. Unfortunately, in 1860/61 the Victorians heavily restored the building, destroying much of its medieval character.

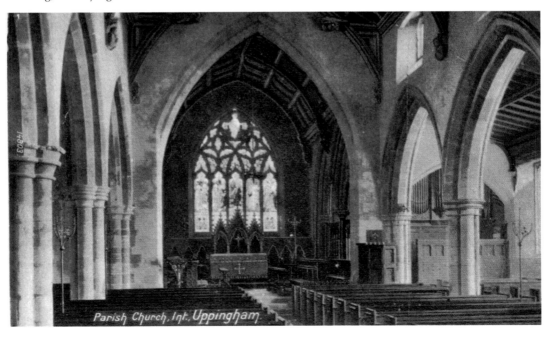

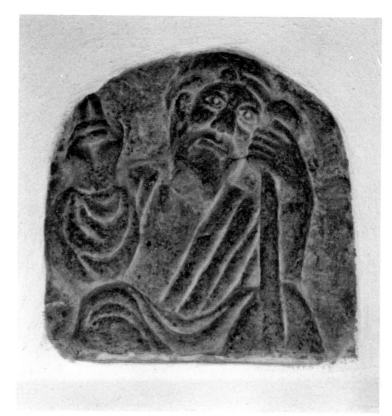

Norman Demi-Figures
Two Norman demi-figures of carved stone, dating from around 1200, in the church of St Peter and St Paul, Uppingham: Jesus Christ and a bearded saint. It is fairly certain that these are Norman carvings.

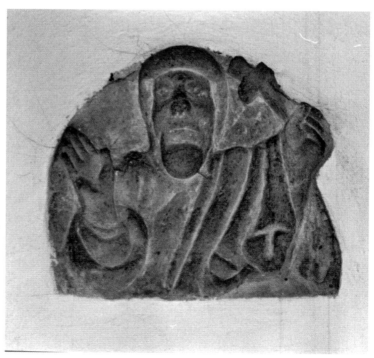

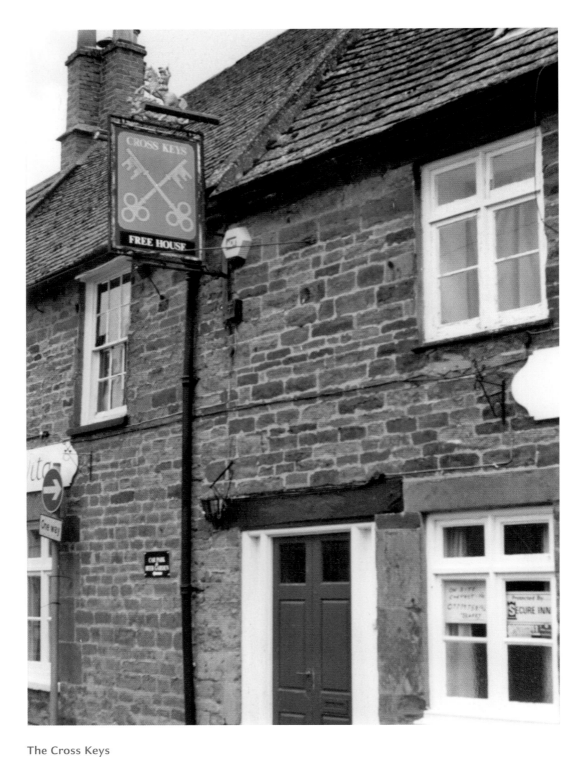

The Cross Keys
An interesting sign hanging above the Cross Keys public house, Queen Street, Uppingham, May 2006, showing the 'keys' surmounted by St George slaying a dragon.

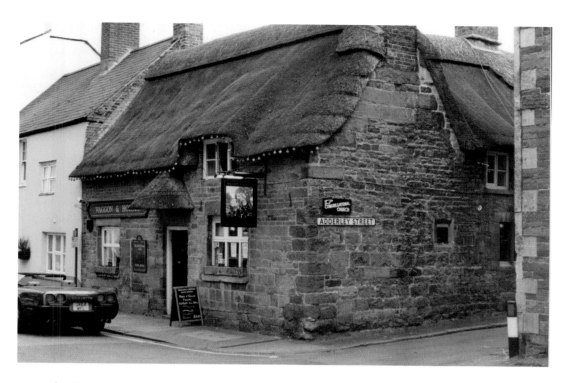

The Waggon & Horses
The Waggon & Horses public house on No. 64 High Street, leading to Adderley Street, May 2006. This historic public house is still maintained with its thatched roof.

High Street
High Street, Uppingham, in 1912.

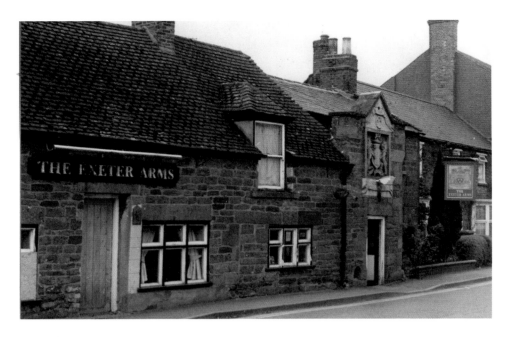

The Exeter Arms
Above, The Exeter Arms public house, Leicester Road, Uppingham, May 2006. Below, the Exeter coat of arms, carved in stone above the entrance to this fine hostelry. The Marquess of Exeter lives at Burghley house near Stamford. This family financed numerous local hostelries on land that they originally owned. This family supported Elizabeth I, and through this connection they established a position in high society that they have never lost.

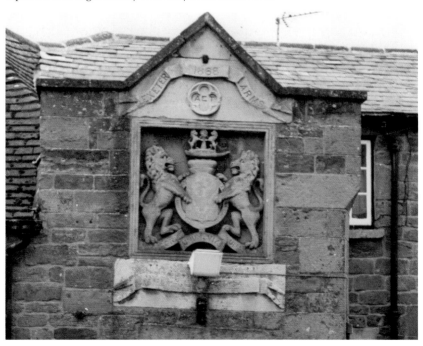

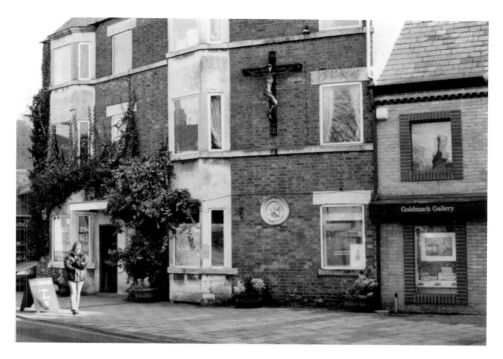

Goldmark Gallery

Above, Goldmark Gallery on Gold Street, Uppingham. The owner, Mark Goldmark, has done much to create national interest in this small market town on fine design, with a particular emphasis on modern art. Below, a display of paintings, prints and sculptures in Goldmark Gallery on Gold Street. It is considered to be one of the most important galleries outside of London to be dealing in modern art.

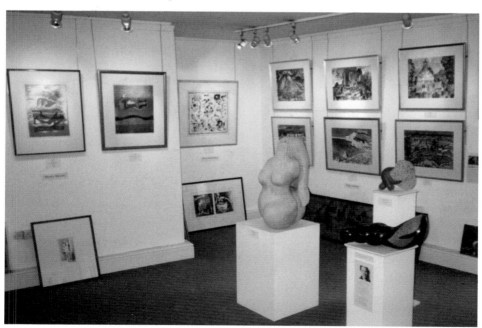

Market Square
The entrance to the market square off the junctions of High Street and Red Hill, Uppingham.

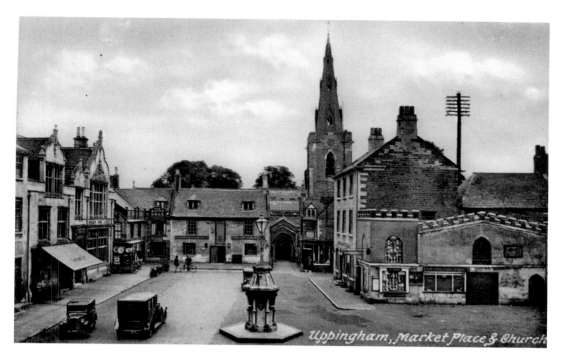

Market Square

Above, the market square, Uppingham, in 1925. The Vaults are in the background with the post office on the right run by Robert William Bingham. High in the background is the church of St Peter and St Paul, and the vicar is Revd George Leyburn Richardson, BD. Below, the Friday market in the front of the Vaults in the Market Place, Uppingham.

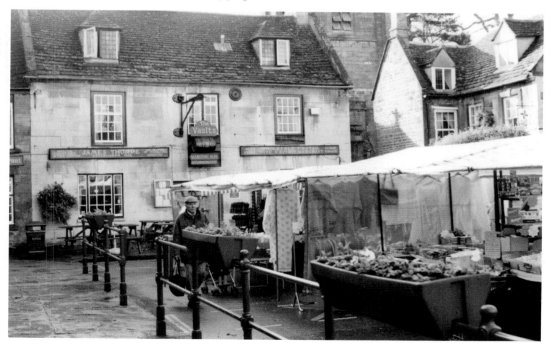

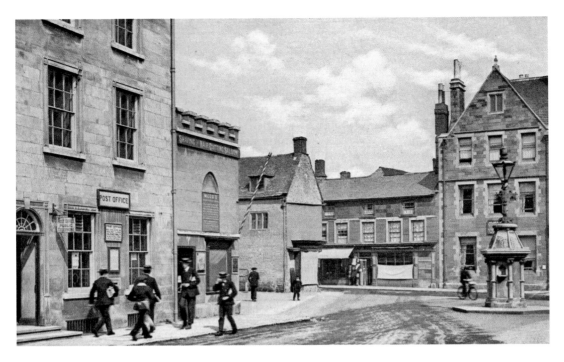

Market Place

Above, the post office on the entrance to the Market Place, Uppingham, in 1942. The postmaster was Henry Alford Reas. On the right is the Falcon Hotel, the licensee of which was John Titley. Below, the entrance to the Market Place, Uppingham, from High Street, with a fine display of vegetables.

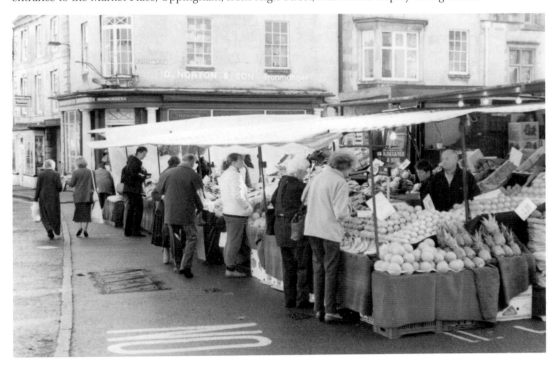

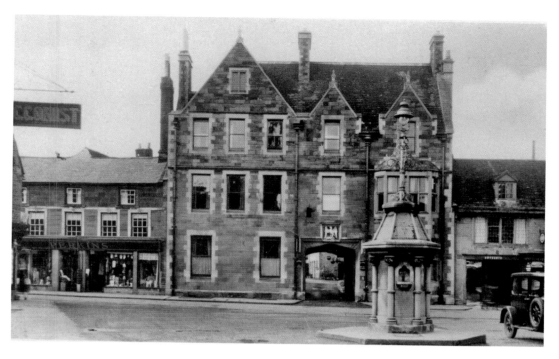

The Falcon Hotel

Above, the Falcon Hotel, 1925 – a fine building. Originally a small inn, it was extensively rebuilt in the nineteenth century. The licensee was Adolph Frances Albert Drake. Below, the farmers' market is held on a Friday in a thoroughfare that runs between the Falcon Hotel and the Uppingham bookshop.

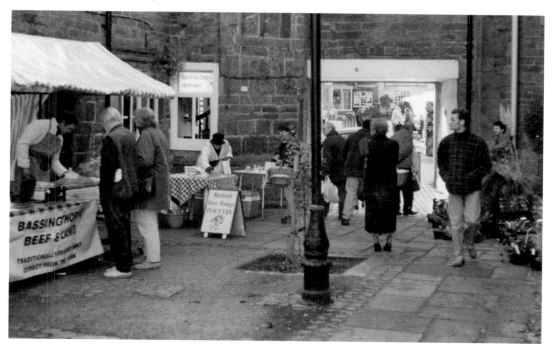

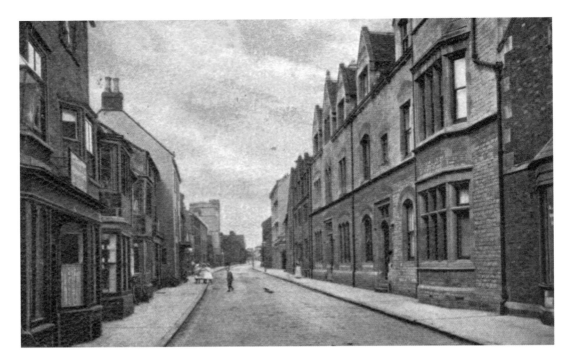

High Street West

Above, High Street West, Uppingham, 1905, with the school hall in the background to the left. Below, a modern view of High Street West. On the left is Edward Baines' bookshop, with school hall in the background.

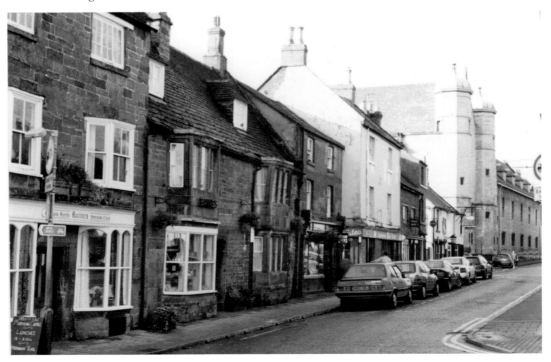

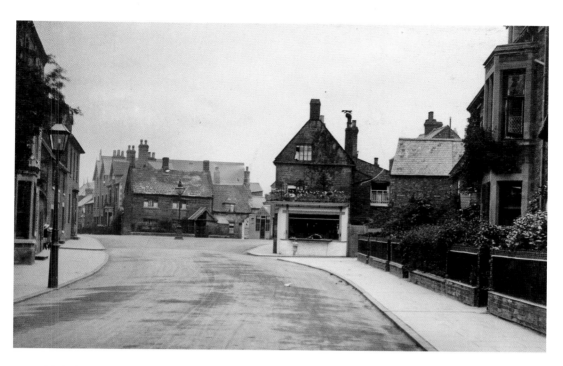

High Street West

Above, the west end of High Street, Uppingham, in the 1930s. Below, High Street West, containing some small interesting shops.

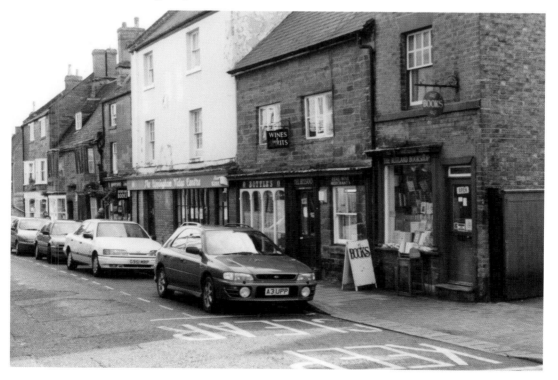

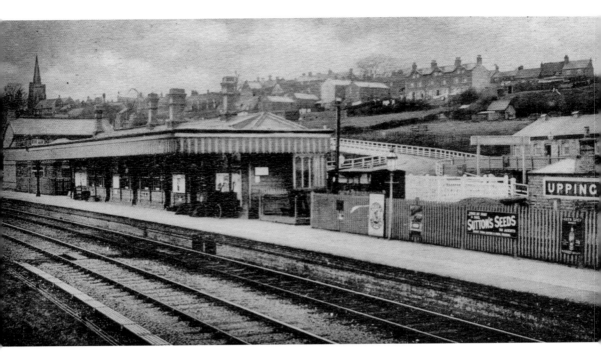

Uppingham Railway Station

Above, Uppingham railway station, situated at the end of South View Lane in 1900. The stationmaster was Henry Rollinson. It opened in 1894 on a branch line from the London & North Western Railway, which was closed in 1964. Below, a train standing in the Uppingham railway station in 1905. In this station's heyday it was a godsend to the students from the public school.

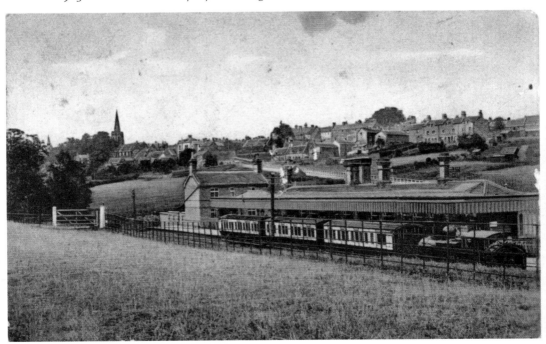

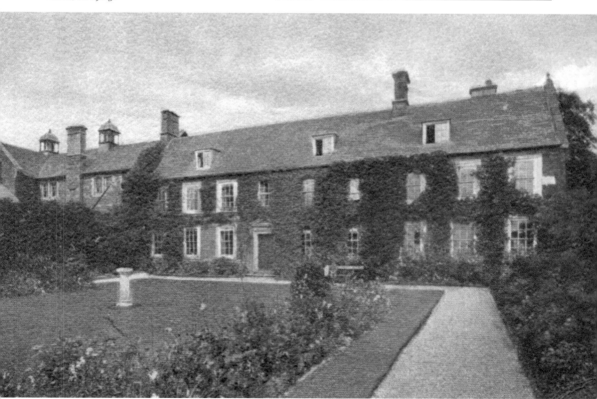

Uppingham Public School
In the following ten pages are a collection of old photographs concerning the public school at Uppingham. Revd Robert Johnson created a school charity in 1584. He was the vicar at the church of St Mary at North Luffenham, and he also founded the school at Oakham. For his endeavours he was created the Archdeacon of Leicester and was presented with this coat of arms. Below, the hall, Uppingham, off South View Lane, c. 1925.

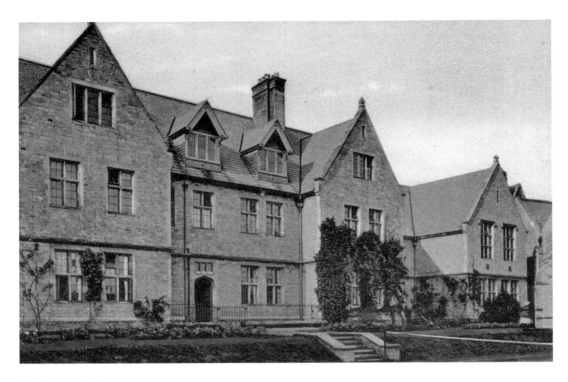

Headmaster's House
Headmaster's House, Uppingham, on Spring Back Way, *c.* 1925.

School House
School House and the shrine at the School Chapel, Uppingham, 1935.

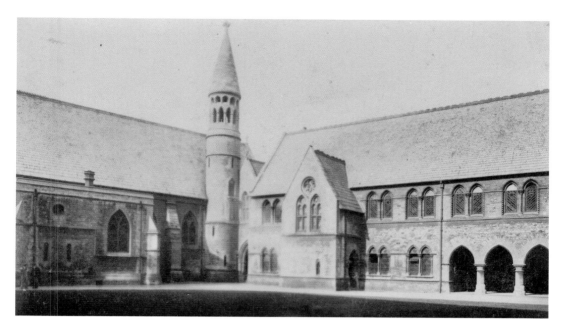

Schoolroom

The schoolroom at Uppingham, constructed in 1863. On the left is the chapel. The turret was added in 1872. These were all designed by G. E. Street.

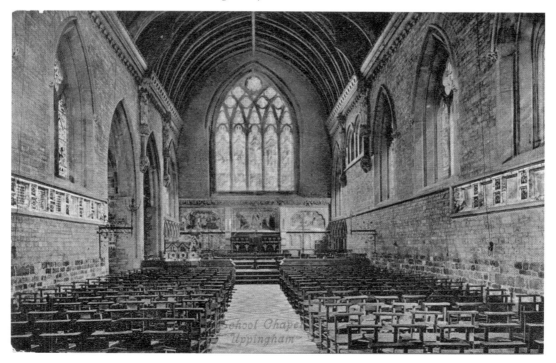

School Chapel

The interior of the school chapel at Uppingham, *c.* 1905.

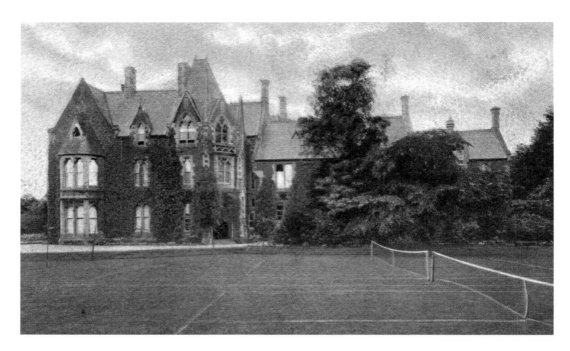

Lower School
Lower School, Uppingham, off Stockerston Road, *c.* 1920.

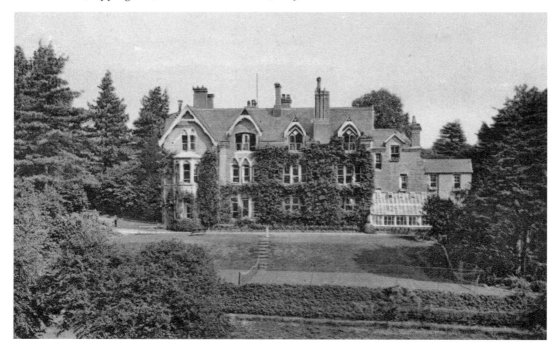

Brooklands
Brooklands, Uppingham, *c.* 1925. Constructed from brick in 1861, it is situated on Red Hill at least half a mile from the centre of the town.

Fircroft

Above, Fircroft, Uppingham, 1942, which came into the possession of the school in 1924. Below, Fircroft, Uppingham, Red Hill; a photograph taken just after the end of the Second World War.

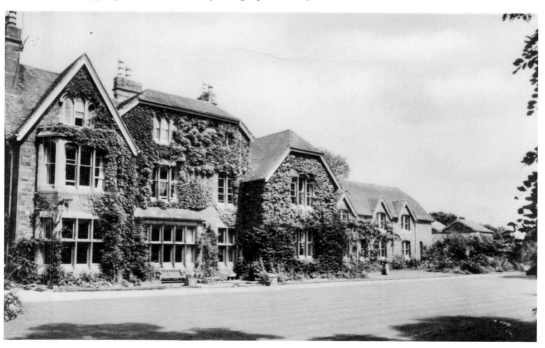

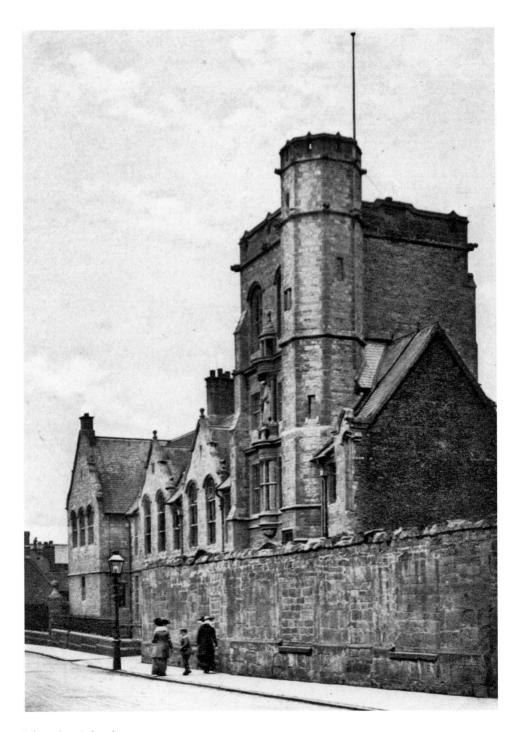

Victorian Schoolroom
The Victorian building constructed by T. G. Jackson to be a schoolroom. The tower would come to dominate High Street, 1910. Unfortunately, the money ran out, and the construction of this school was cancelled in the 1920s. It never met the full requirements of Jackson's design.

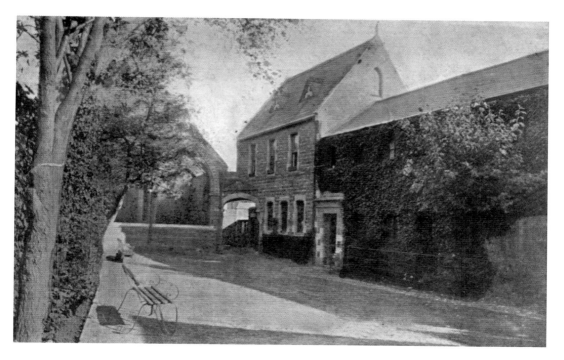

The Constables

Above, the Constables in 1917, run by Revd W. J. Constable. Below, the new Constables on Leicester Road, created during the years 1928/29, when cottages were purchased by the school on School Lane and then demolished.

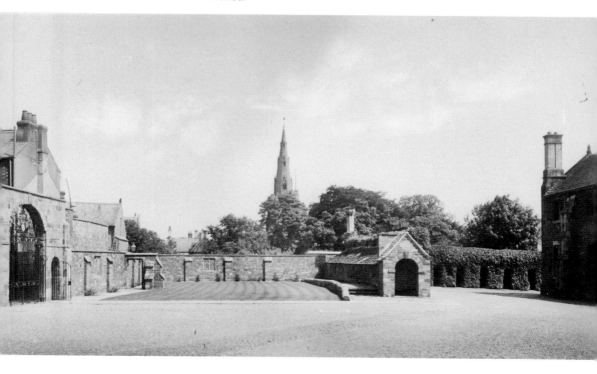

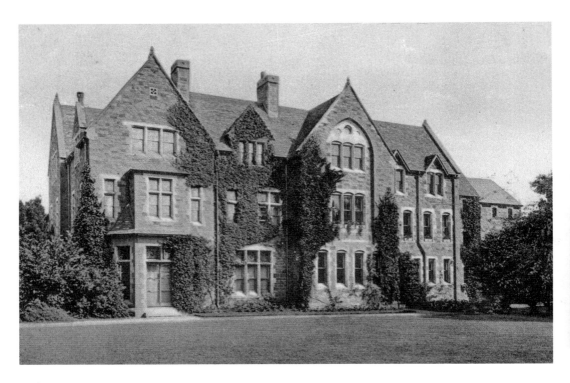

Redgate
Redgate, on Red Hill, Uppingham, *c.* 1920.

West Deyne
West Deyne on the High Street, Uppingham, *c.* 1920.

Meadhurst
Above, Meadhurst on Ayston Road, Uppingham, *c.* 1920. Below, Meadhurst, *c.* 1930.

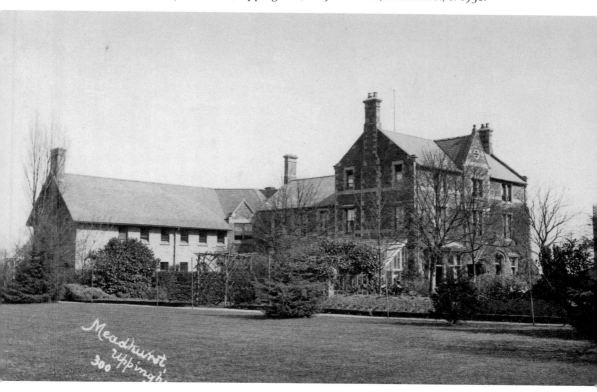

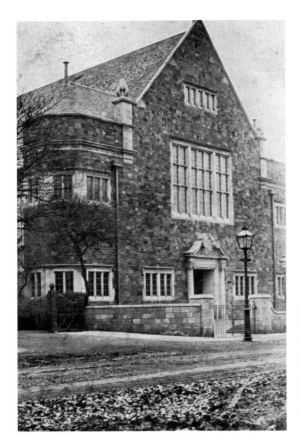

Uppingham School War Memorial
Uppingham School War Memorial Hall, recording those scholars that lost their lives in the Boer War. This was opened by Field Marshal Earl Roberts VC KG on 30 March 1905. Below, Lord Roberts inspecting the Uppingham School cadets on the opening of the war memorial in March 1905.

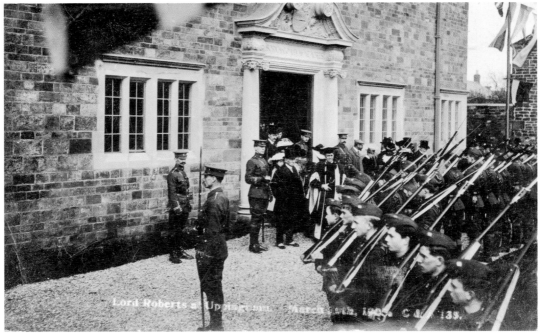

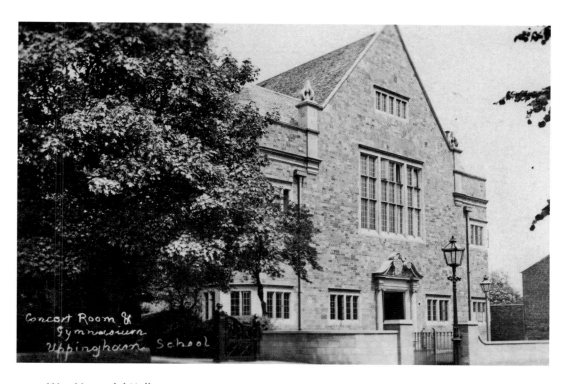

Concart Room &
Gymnasium
Uppingham School

War Memorial Hall

Above, the War Memorial Hall at Uppingham in 1916, which has now been renamed the Concert Room and Gymnasium. Below, Uppingham School Hall on the High Street in the 1940s.

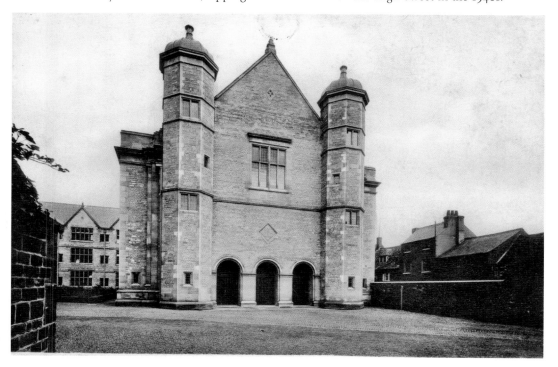

Acknowledgements

Trevor Hickman built up his collection of photographs and illustrations over very many years, beginning in 1948 when his mother gave him some old postcards covering the village they lived in. For the last sixty years he has continued to add to his collection. When his daughter Sharon worked at Uppingham School he was given a selection of school photographs, recording the various houses. These comprise the major part of the final chapter in this book. Research in the surrounding villages was made possible with the help of his wife Pam, his granddaughter Amy Grech and Jenny Weston. The author records his grateful thanks for all those who have helped in collating this book.

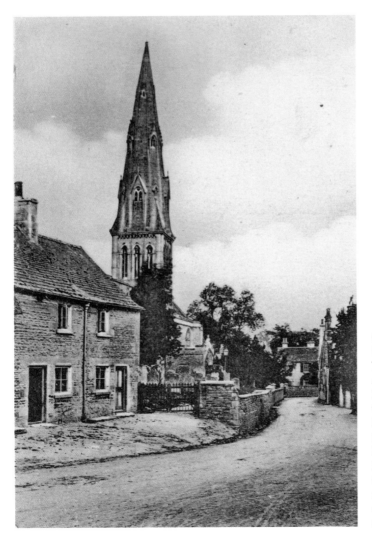

Church of St Mary, Ketton, 1916
The vicar was Revd Arthur Snowdem, MA. This photograph was taken at the height of the First World War. Numerous villagers failed to return after this conflict and their names are engraved on the war memorial, erected in the 1920s.